China [sur]real

Published by Timezone 8 Limited 2006
e-mail: info@timezone8.com
www.timezone8.com

Photography: Mark Henley
Book Design: Eliot Kiang & Qian Cheng
Introduction: Ed Lanfranco
Cover Photos by Mark Henley

ISBN: 988-99265-6-3

Printed in China

With support from:

Schweizerische Eidgenossenschaft
Confédération suisse
Confederazione Svizzera
Confederaziun svizra

Swiss Confederation

Département fédéral des affaires étrangères DFAE
Federal Department of Foreign Affairs DFA

To my father William Henley

Exploring [sur]real China

Mark Henley's collection of images in **China [sur]real** provides unique insights into the challenges of fast changing realities within the Chinese universe. Unless one is a Sinologist, places like Shenyang, Baotou and Chongqing may not be on one's mental map today, but cities similar to these, plus hundreds more growing like them, are having their impact felt across the earth.

The most important feature of these photographs is that they serve to remind us that despite all the things humanity shares in common, the frames of reference which define meaning in our lives vary: it's the same planet, but different worlds.

The parenthetical division of surreal in the title illustrates the need to separate the reality from the centuries old perception of China as otherworldly, possessing an indescribable bizarre dreamlike strangeness, descriptions Westerners, unable to fathom their surroundings, have used since first encountering the civilization. Mark Henley captures the common humanity and does not omit the odd edges that makes China part of our world, yet a world apart.

China [sur]real portrays people and processes of 'Zhongguo,' the 'Middle Kingdom' in the midst of its greatest transition; the nature of what constitutes authentic in its physical and mental worlds is evolving. The passing days and nights in China makes understanding what constitutes real in the most populous nation-state a fascinating exercise, open to new interpretations.

Few places worldwide rival the People's Republic of China for the pace, scope and sustained duration of its ambitious transformation from a predominantly rural to city-based society. The policy is motivated by the notion that urbanization offers the organization and concentration necessary to meet basic human needs in a more equitable and efficient manner.

The magnetic allure of the glittering lights and the towering monuments of infrastructure and architecture is tempered by a hard truth: cities are not places of equality or efficiency but instead serve up a bewildering array of often gritty alternatives and opportunities within a complex hierarchical dynamic. For more than 15 years Mark Henley has captured with care and artistry extraordinary moments of ordinary people caught in a constantly shifting unknown.

The accelerating urban revolution boils down to the issue of choice. The die was cast more than a quarter century ago with Deng Xiaoping's decision to introduce market-driven economic incentives in selected cities starting with the isolated laboratory experiment in Shenzhen, then little more than a backwater village on the border with Hong Kong.

From the initial success of combining entrepreneurial spirit with foreign capital and abundant labor from the countryside geared toward export-oriented growth, the experiment spread to coastal cities, provincial capitals and now second and third tier cities thanks to hundreds of millions of Chinese leaving thousands of hamlets in search of a better life.

The photographs in **China [sur]real** highlight the predicament of the individual for many of the toughest choices confronting contemporary urban society. How the Chinese choose to manage internal migration and address economic inequalities while its consumer culture and sexual liberation expands are noteworthy, but the decisions concerning environmental degradation and resource consumption, fueling urban growth, influence city limits for the entire global village.

Mark Henley's sharp eye juxtaposes the iconic with the ironic, brings out the humor in highly improbable, seemingly impossible and farfetched situations. The result of his labor, now in your hands, is the fruit of 17 years traveling throughout the country exploring the notion of what is real in China.

- Ed Lanfranco
Beijing Bureau Chief, United Press International

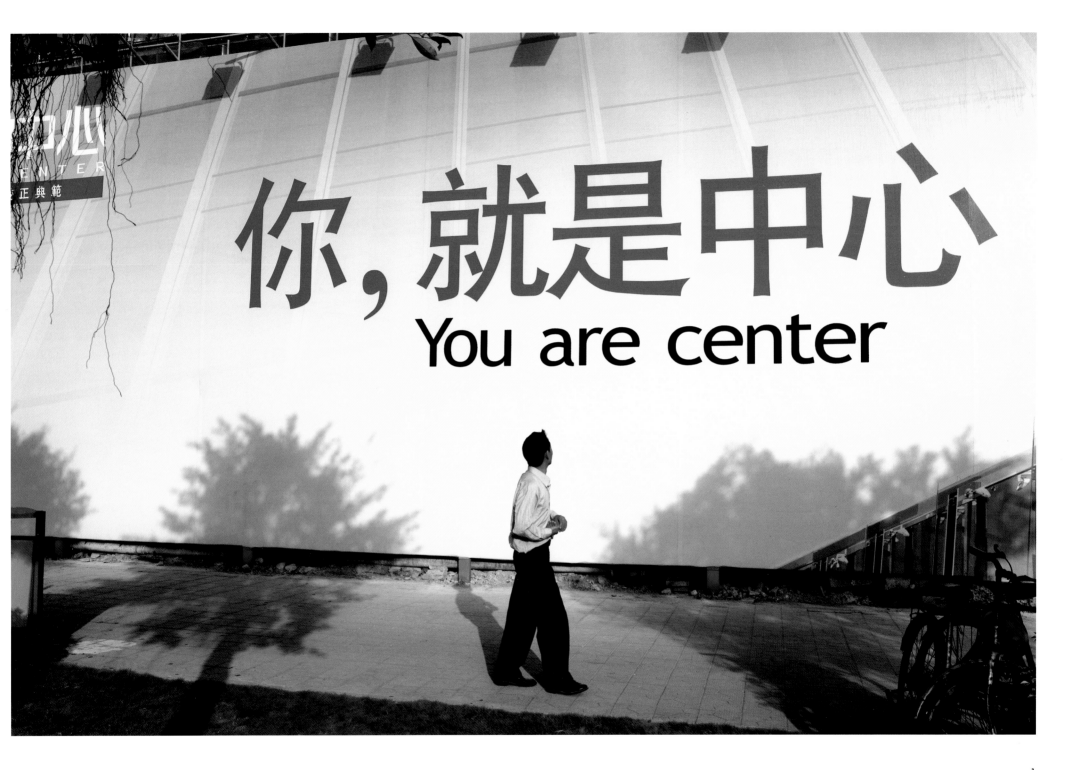

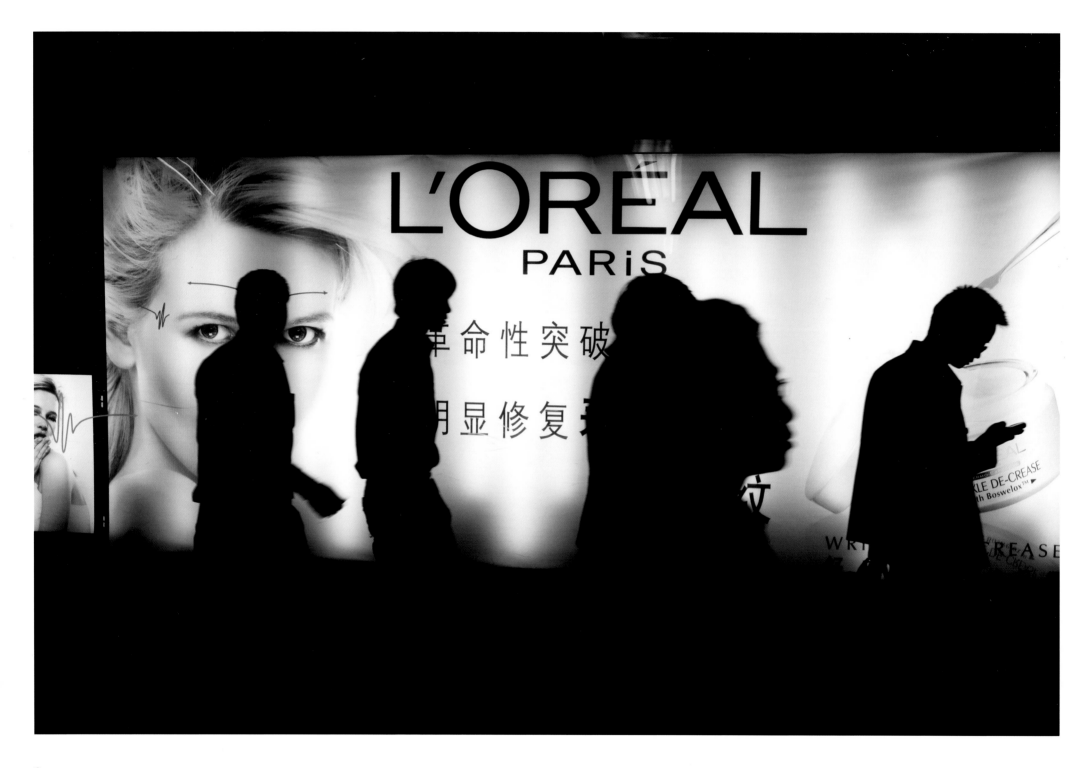

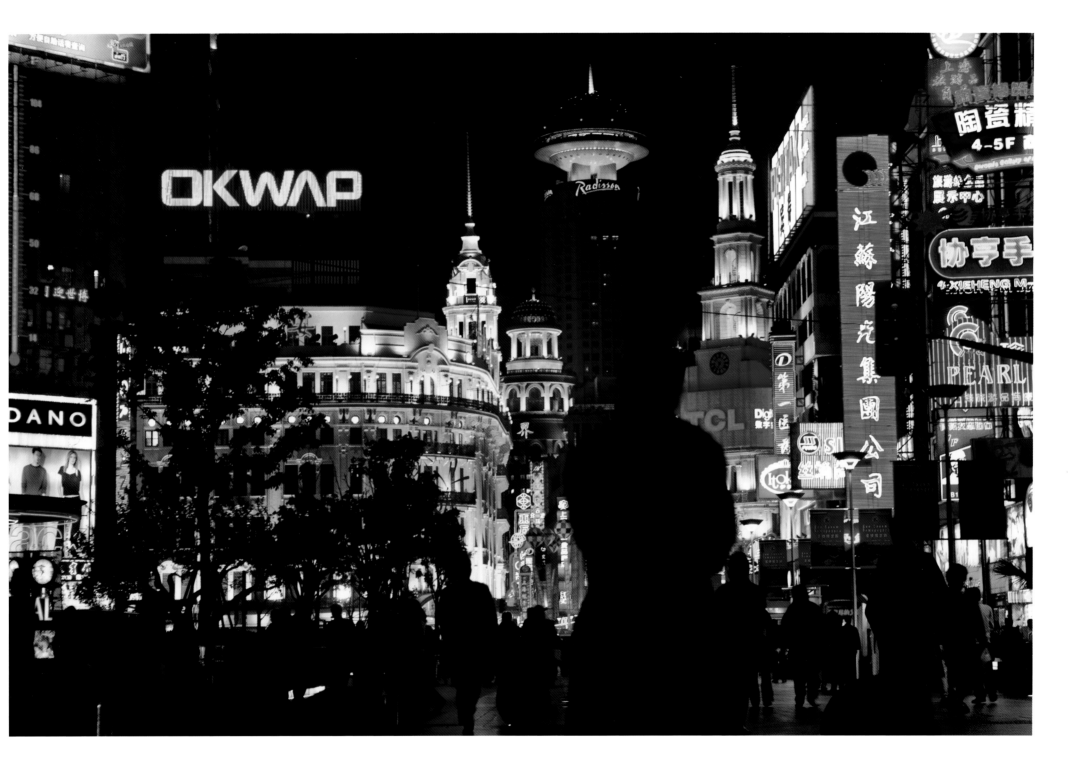

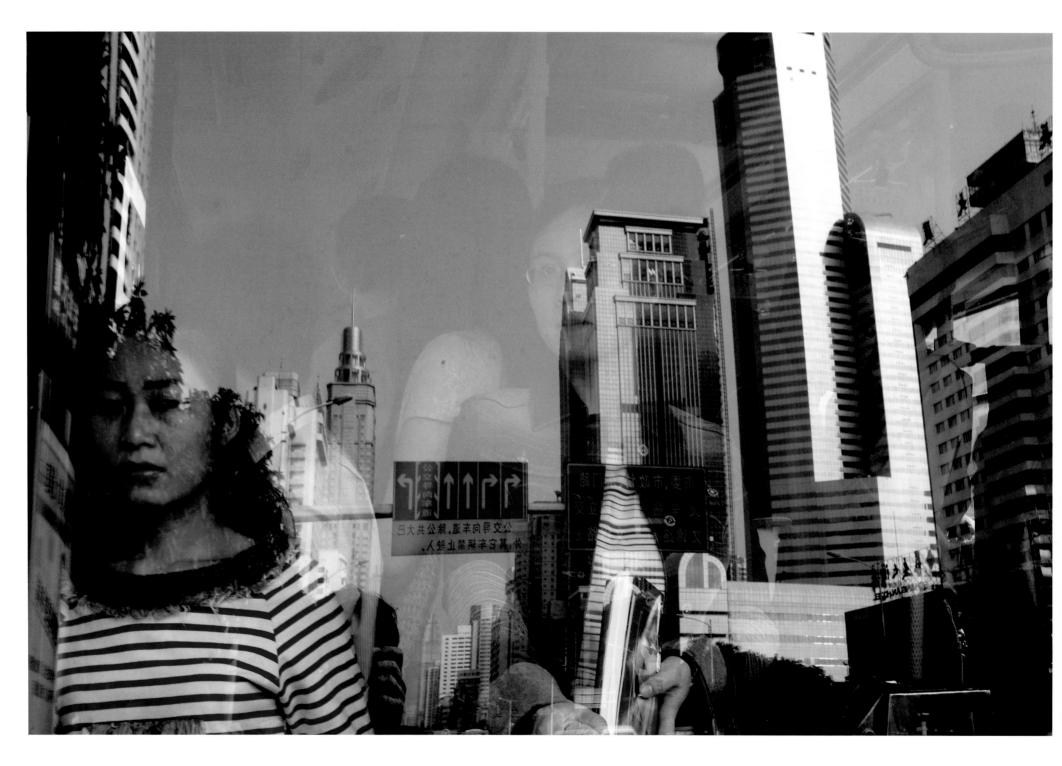

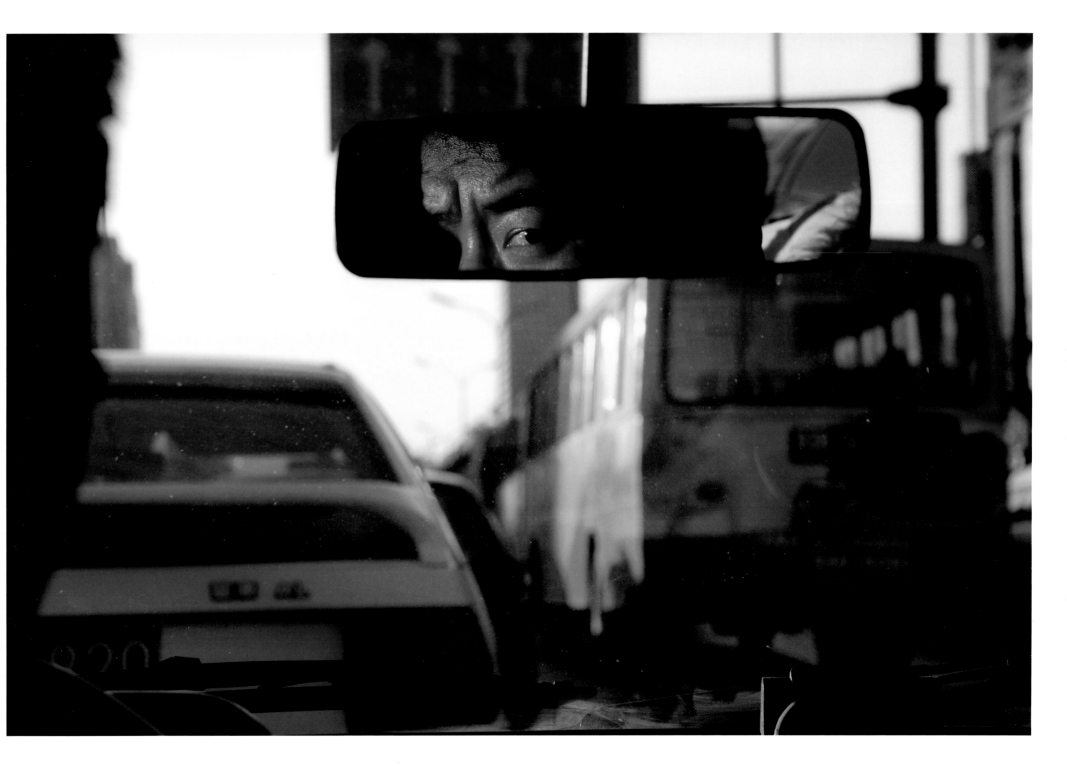

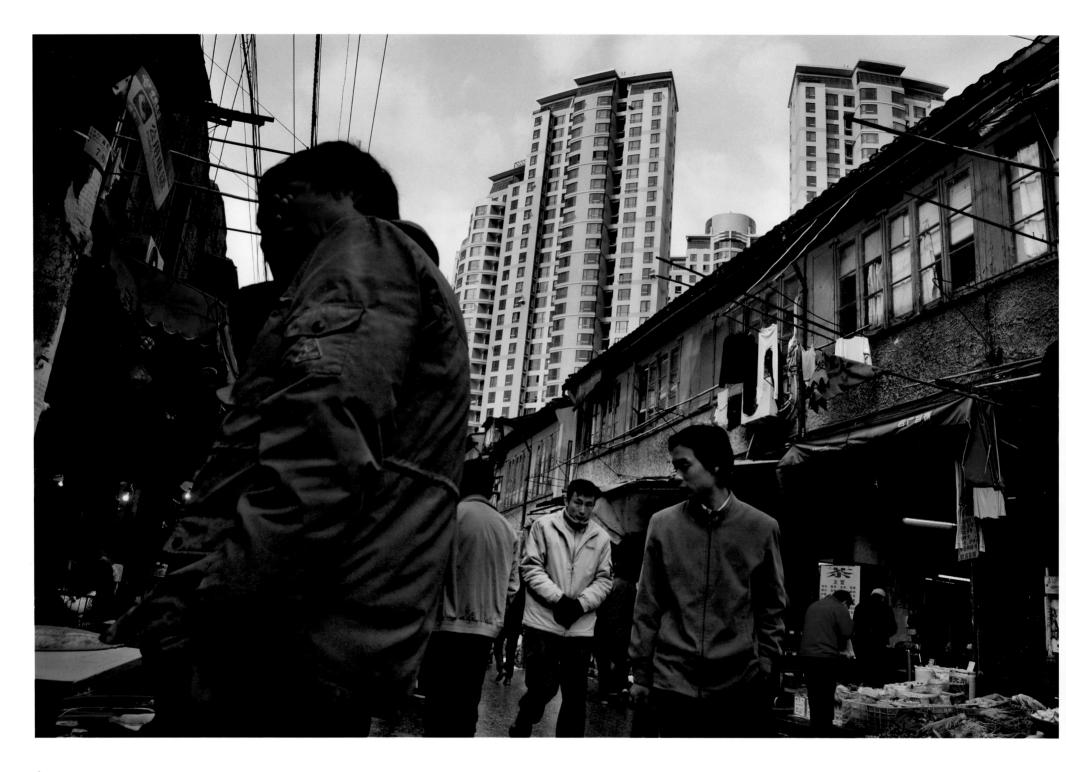

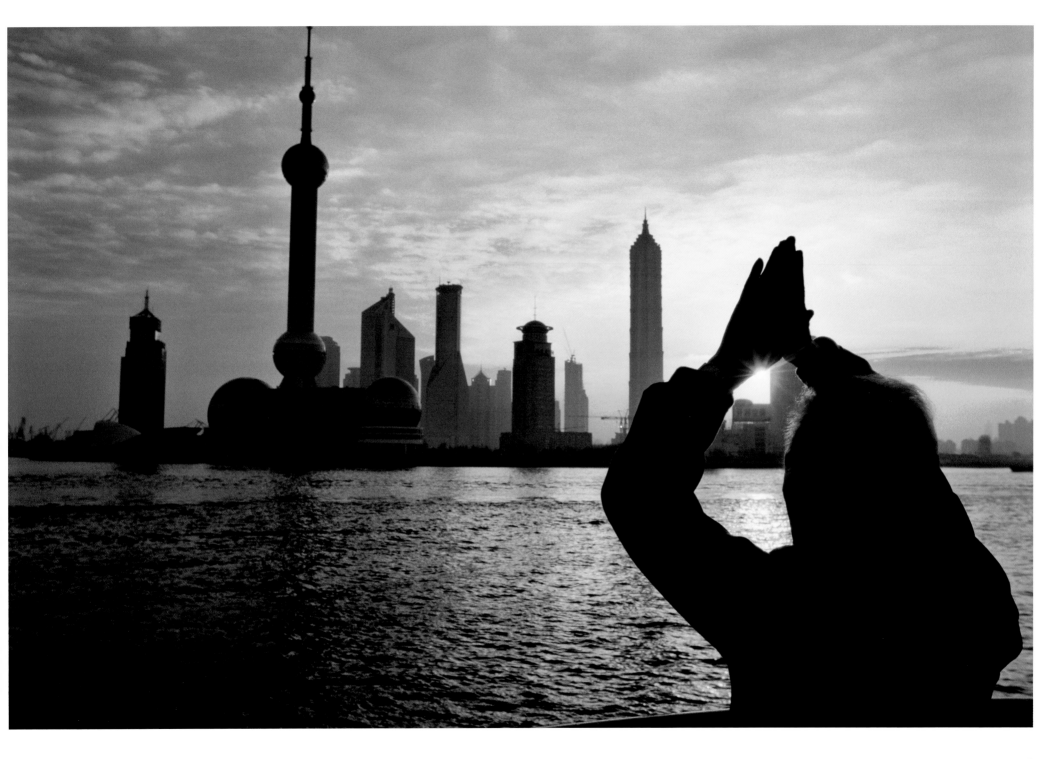

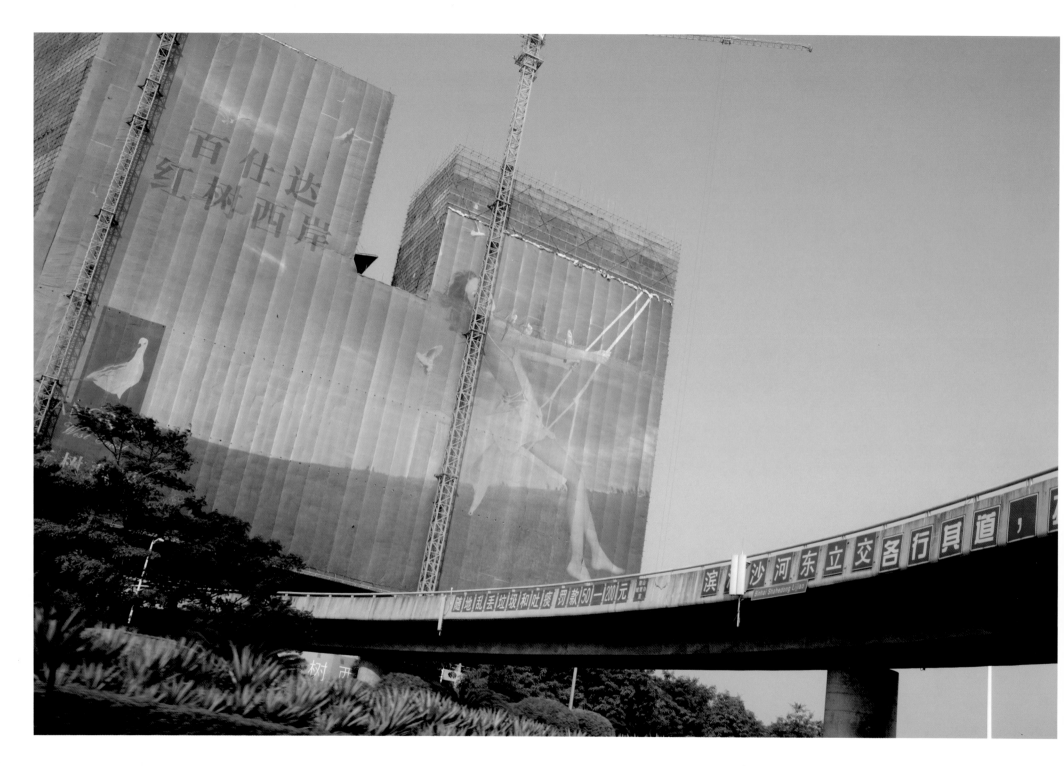

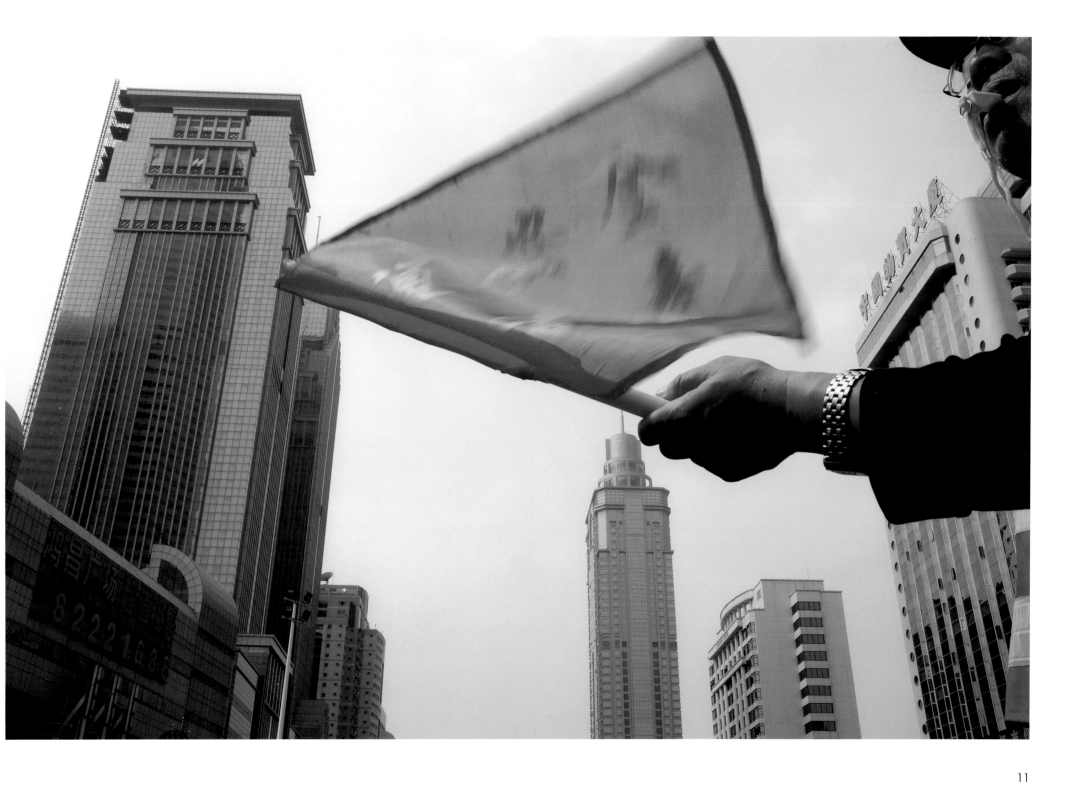

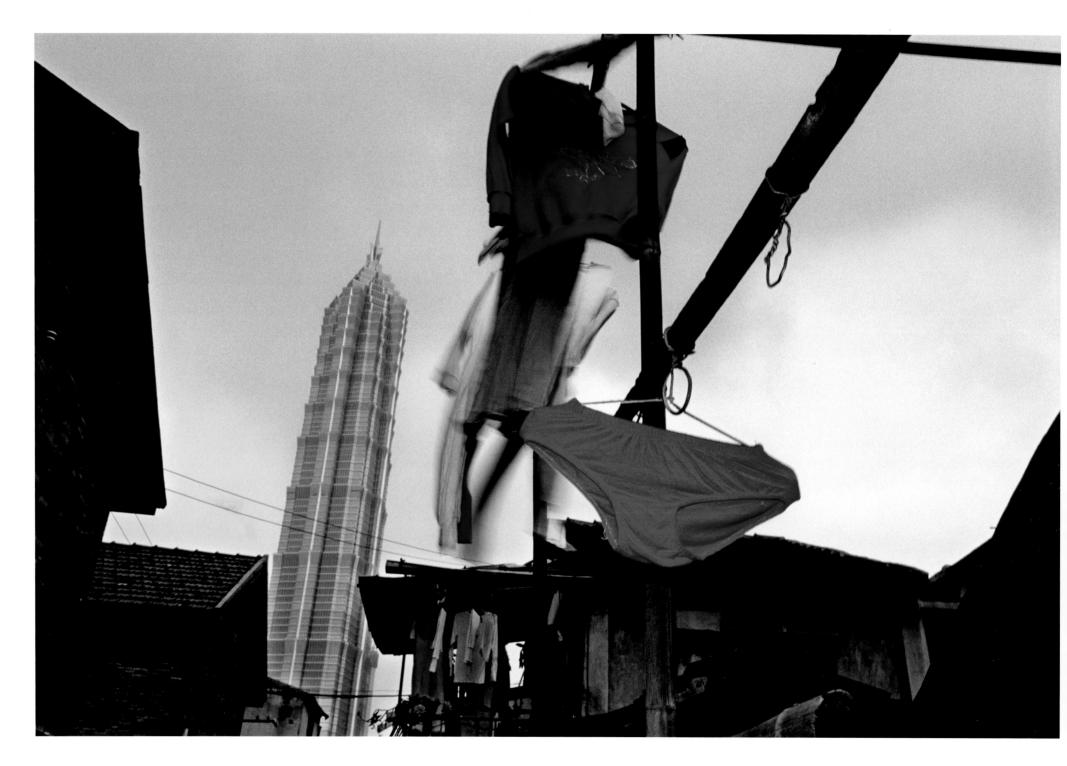

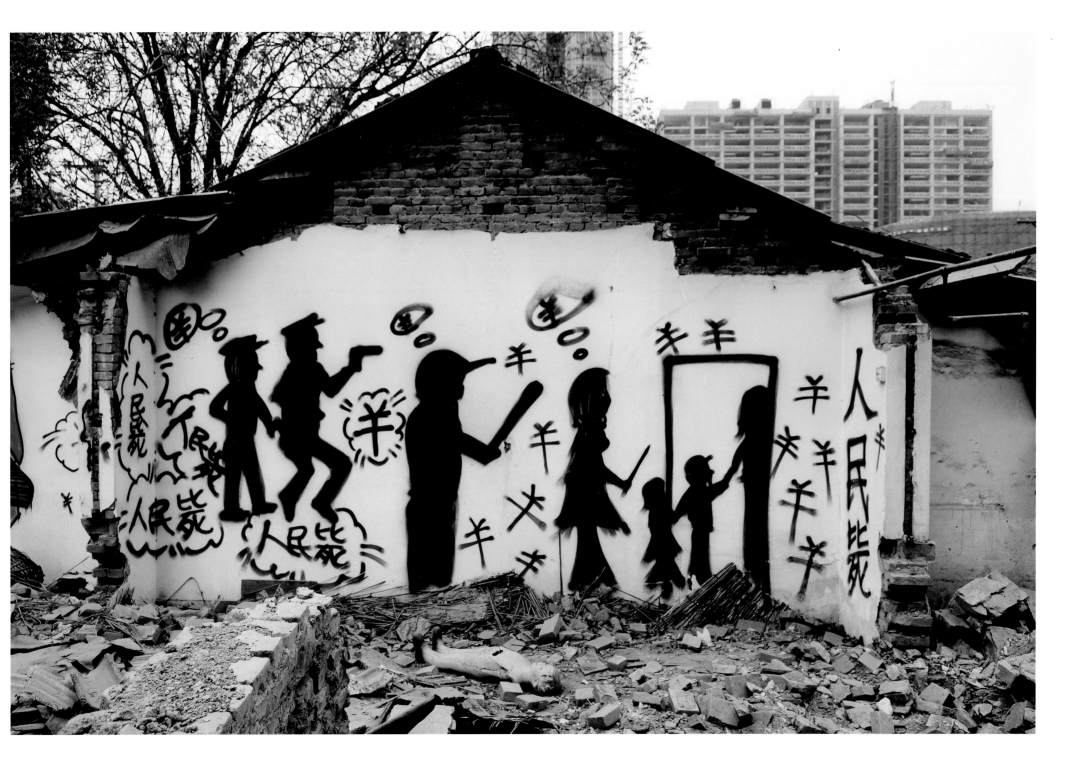

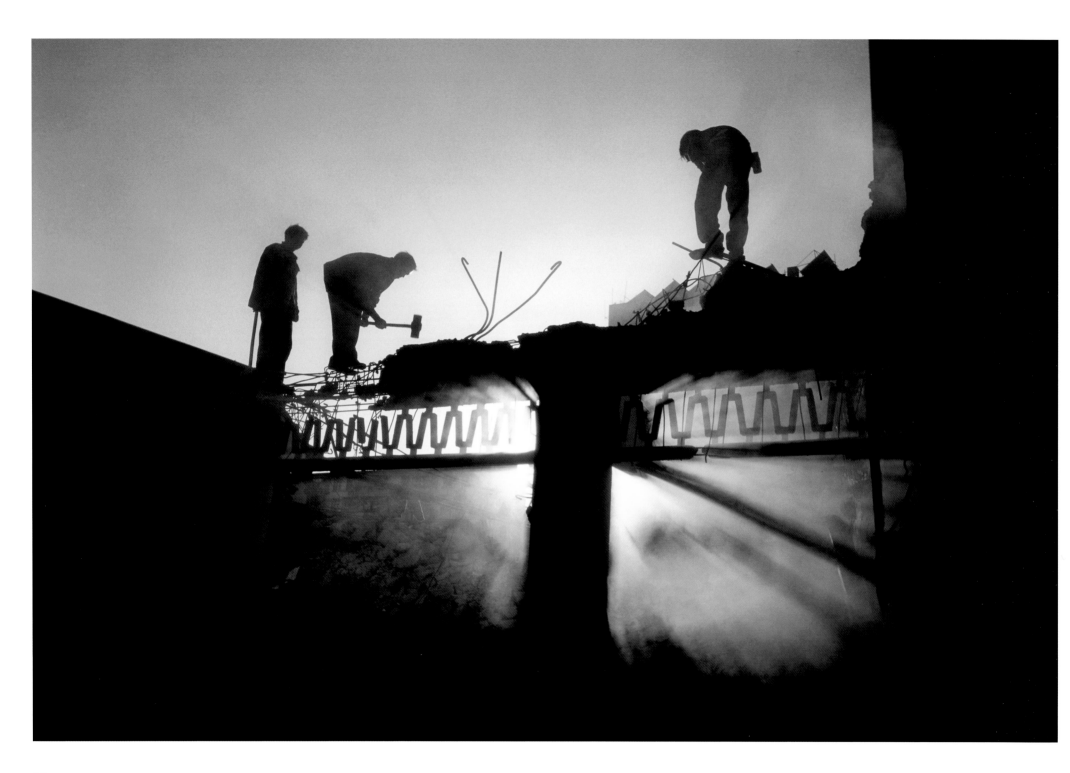

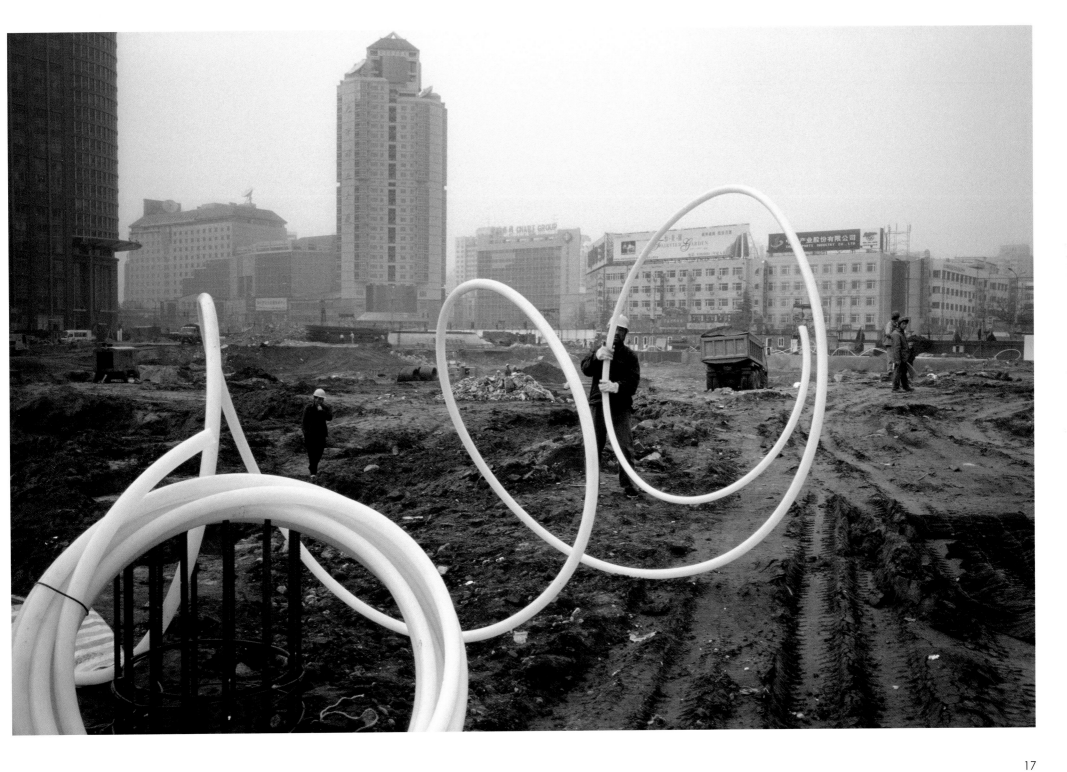

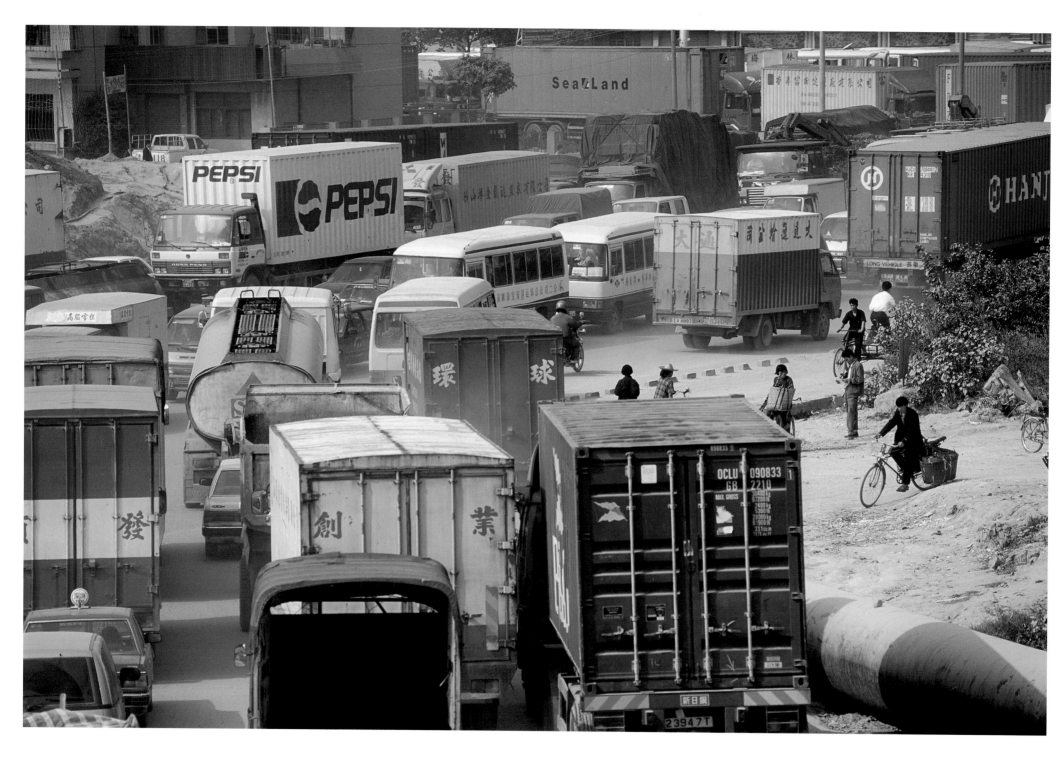

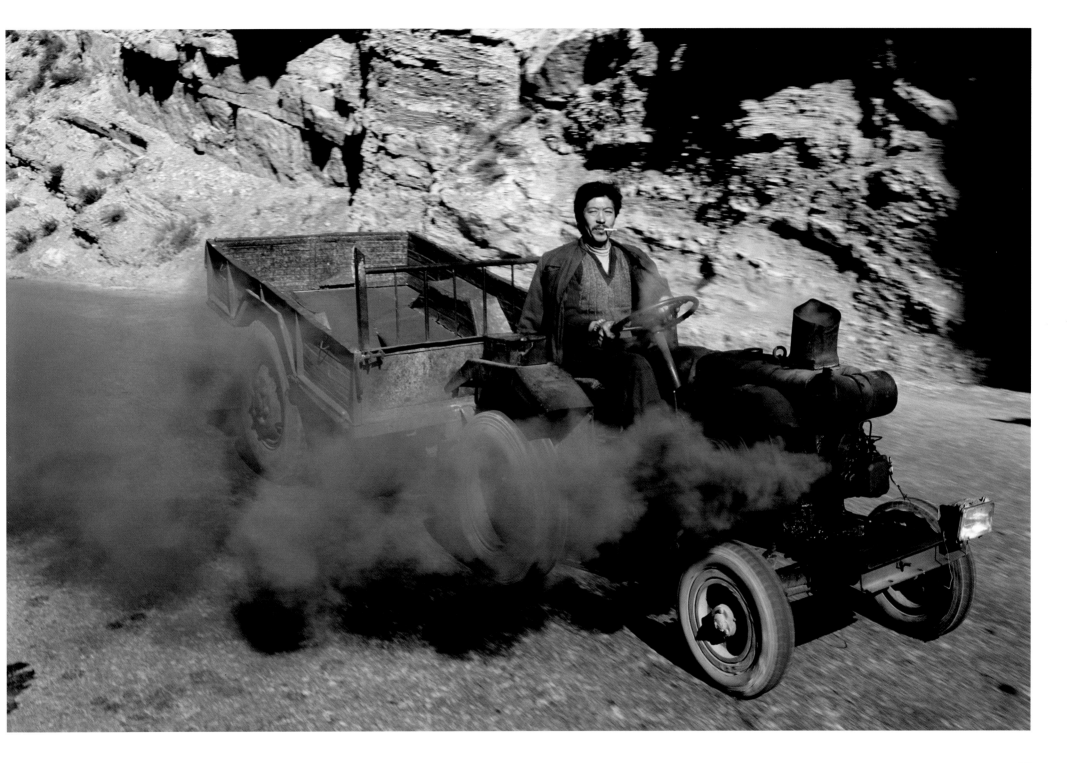

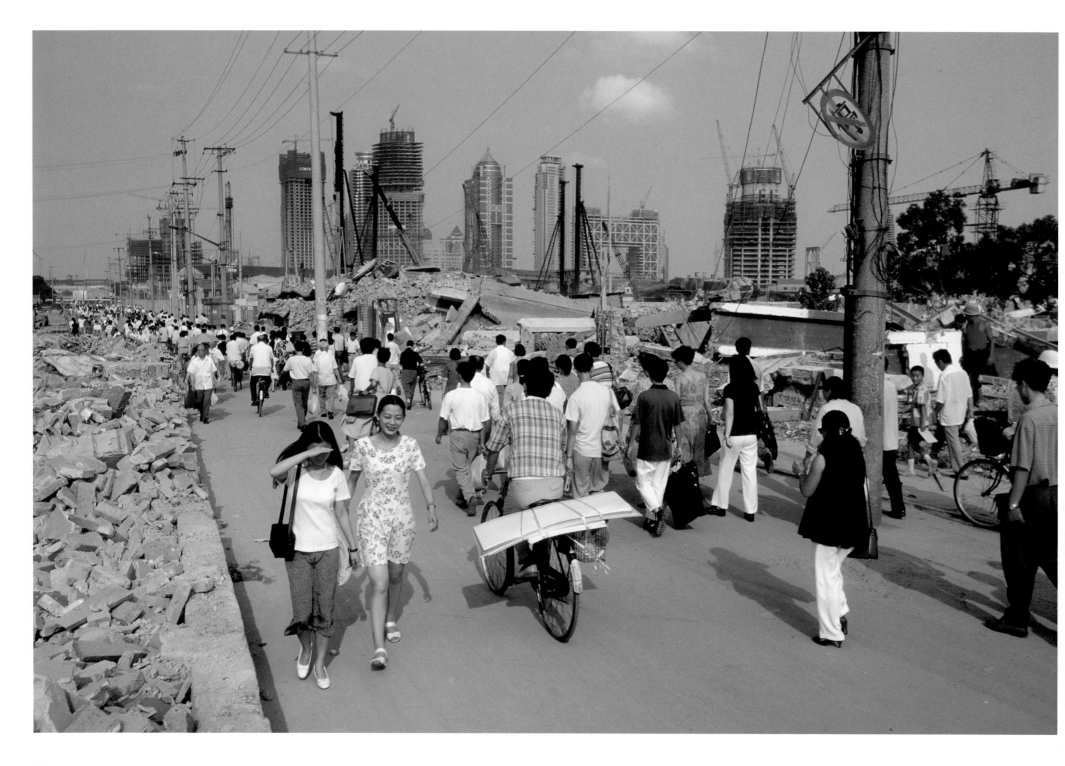

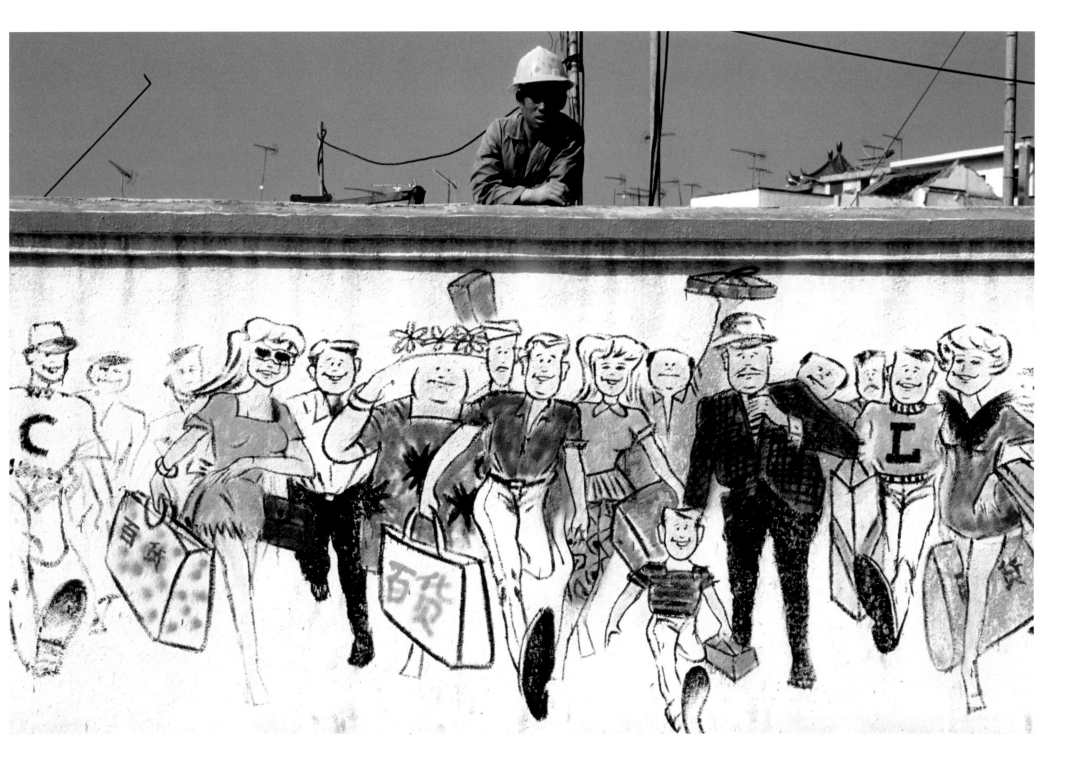

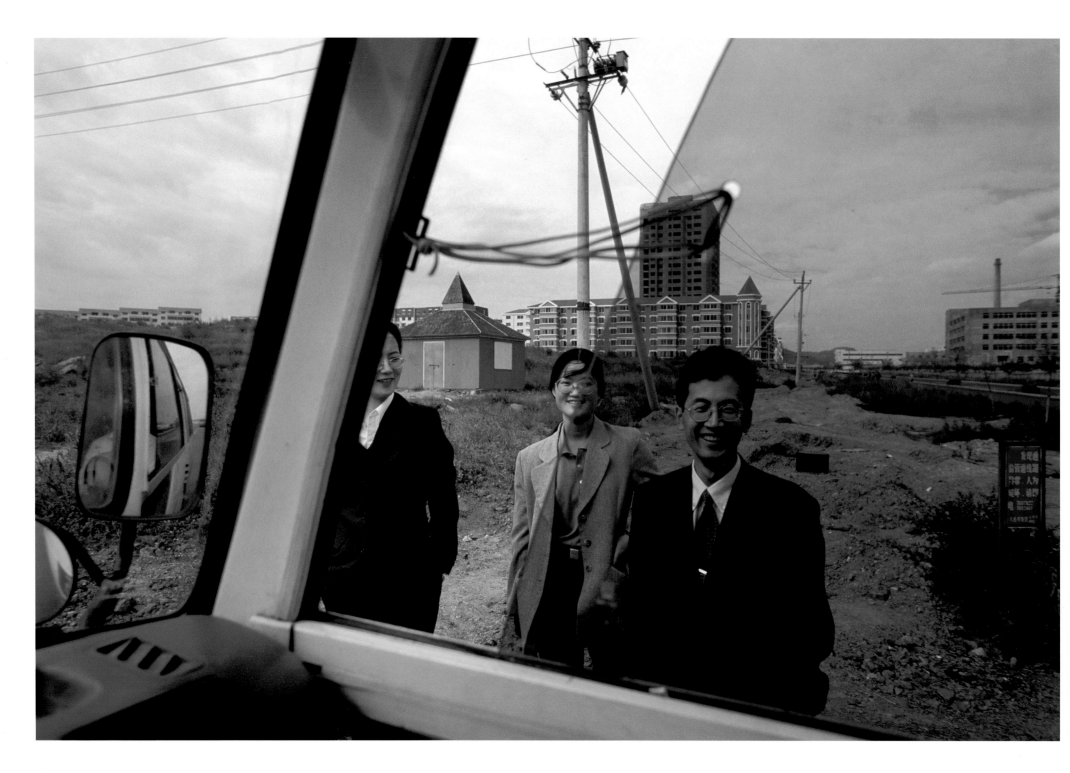

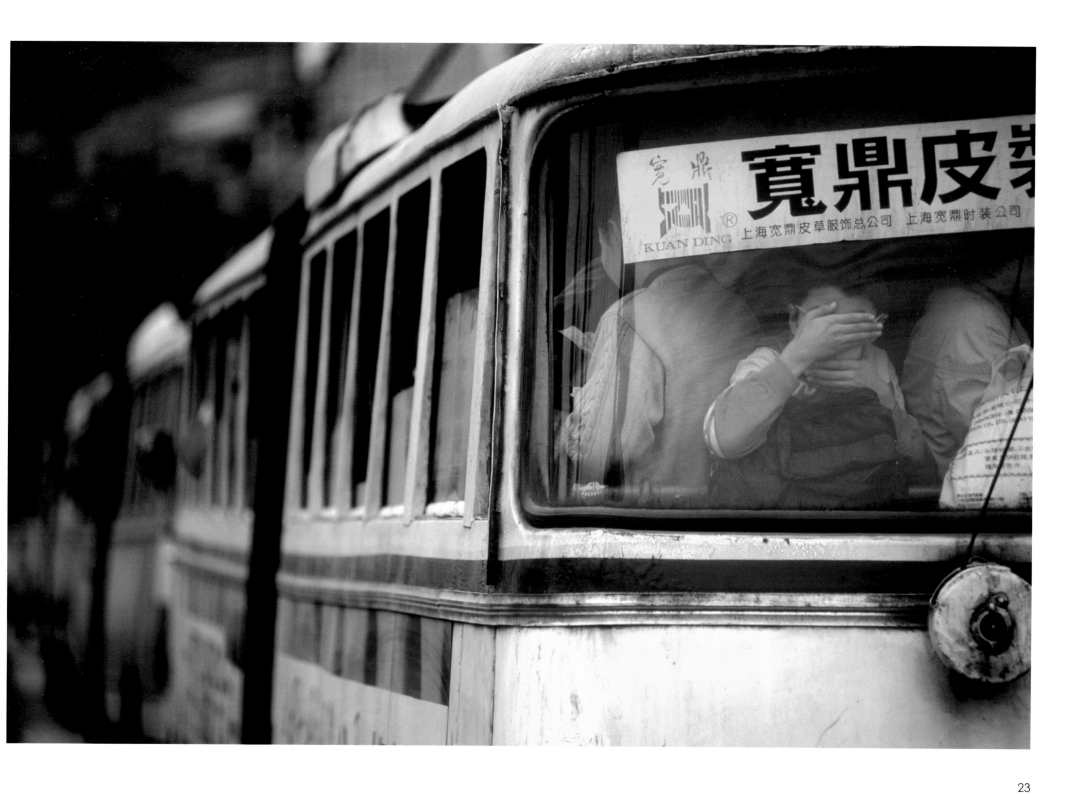

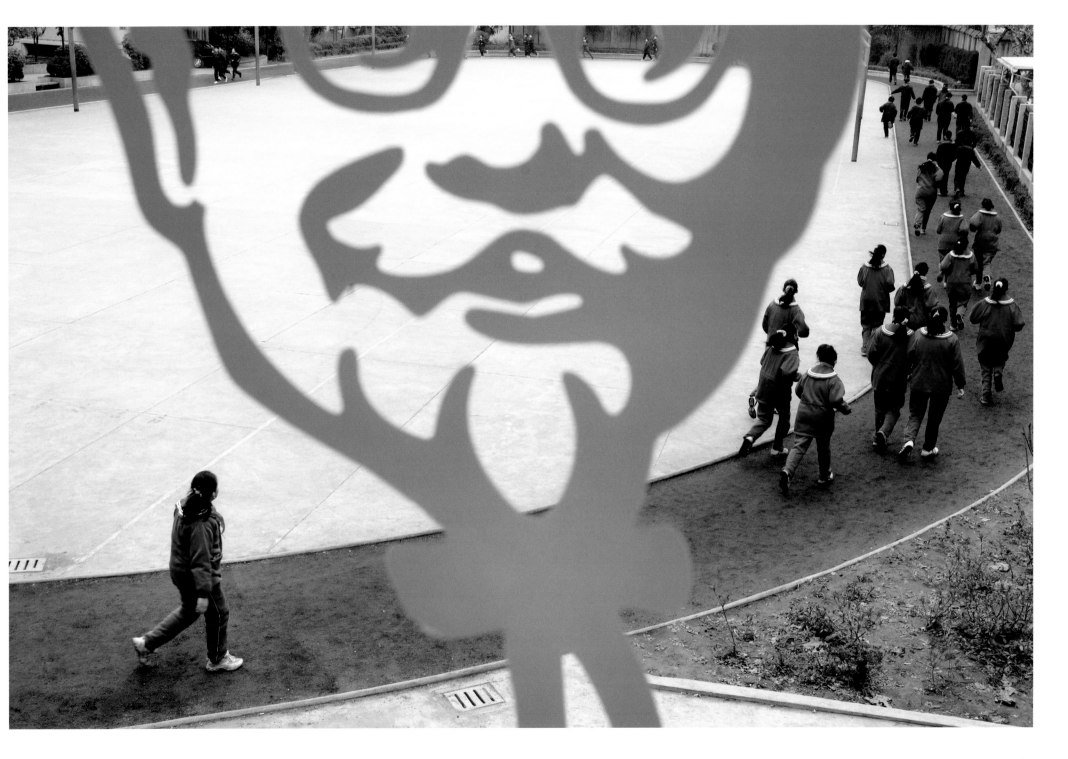

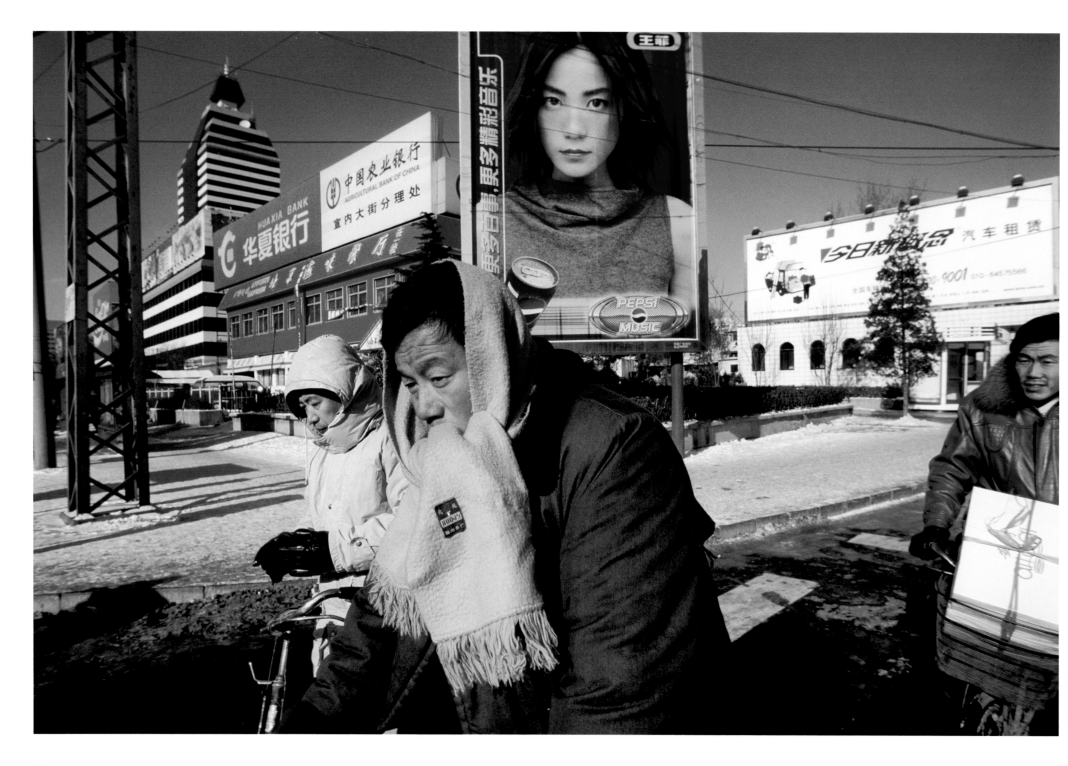

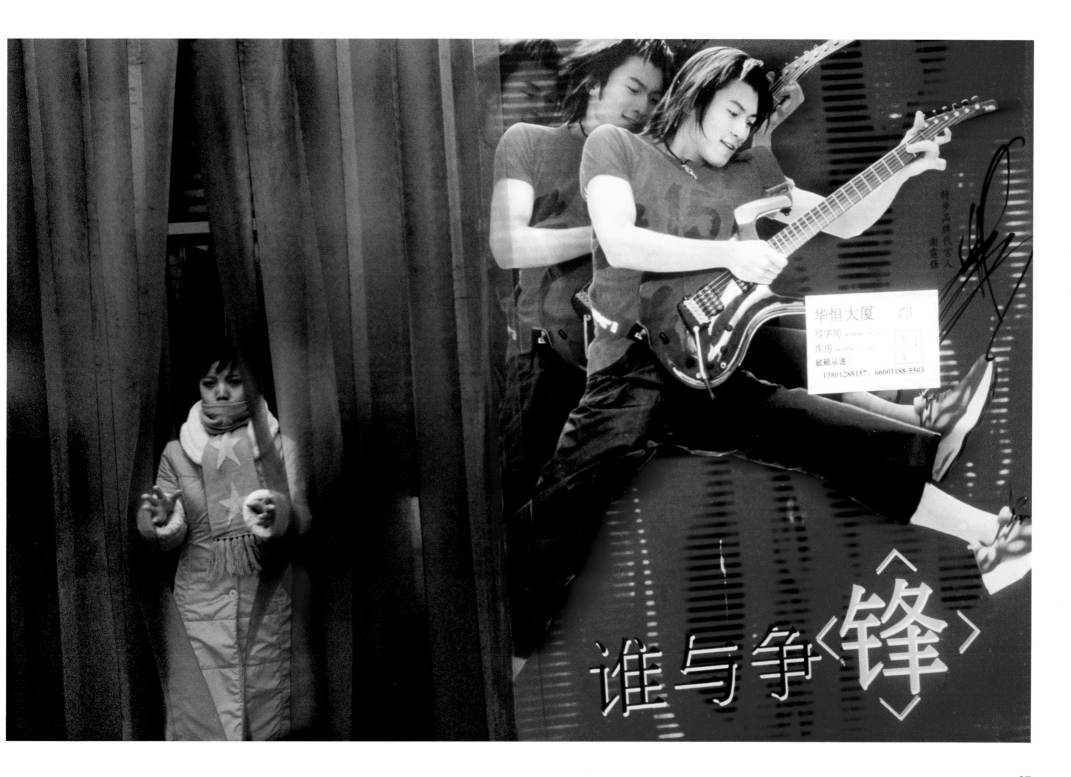

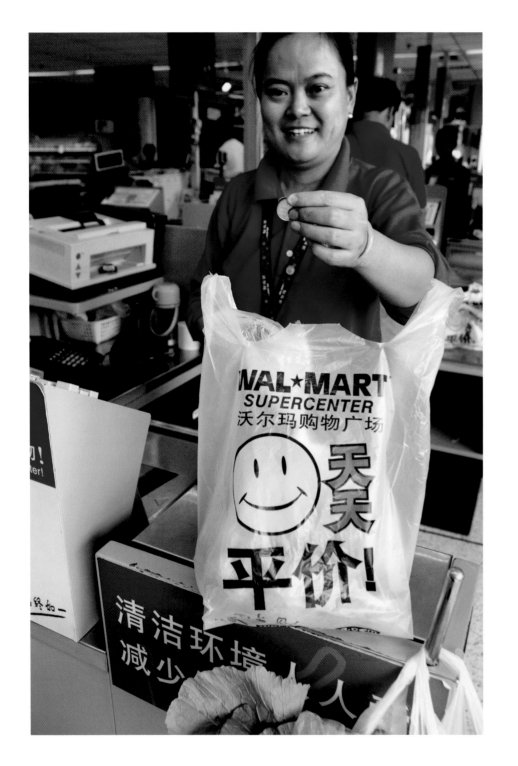

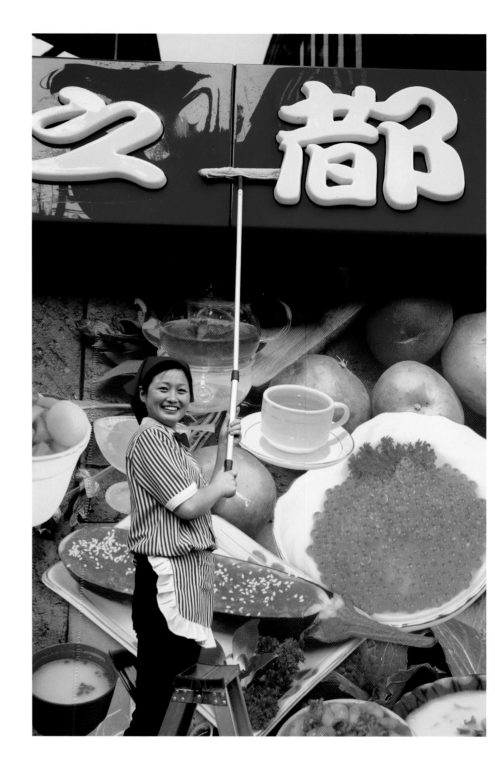

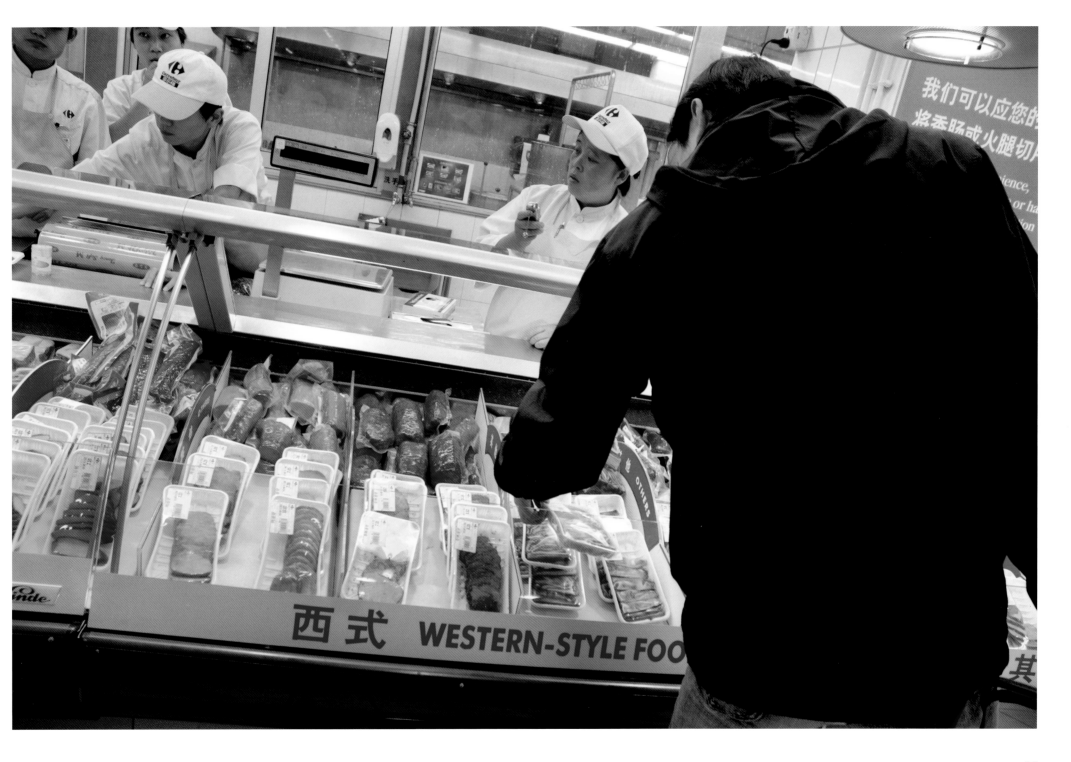

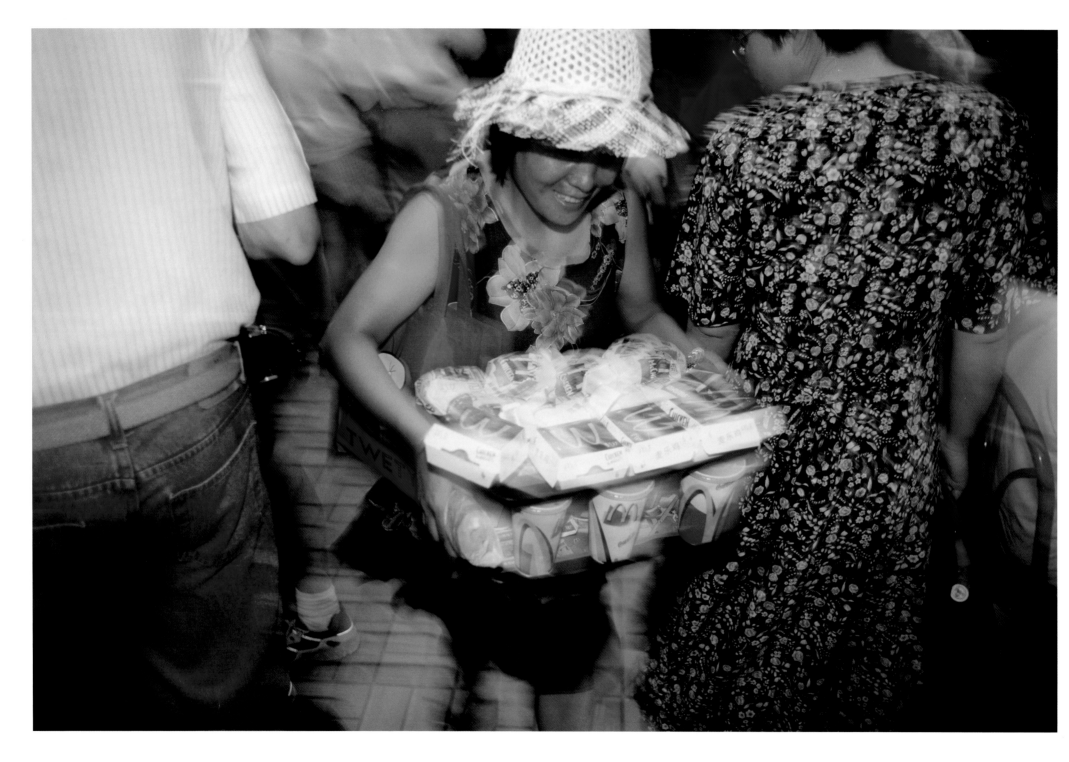

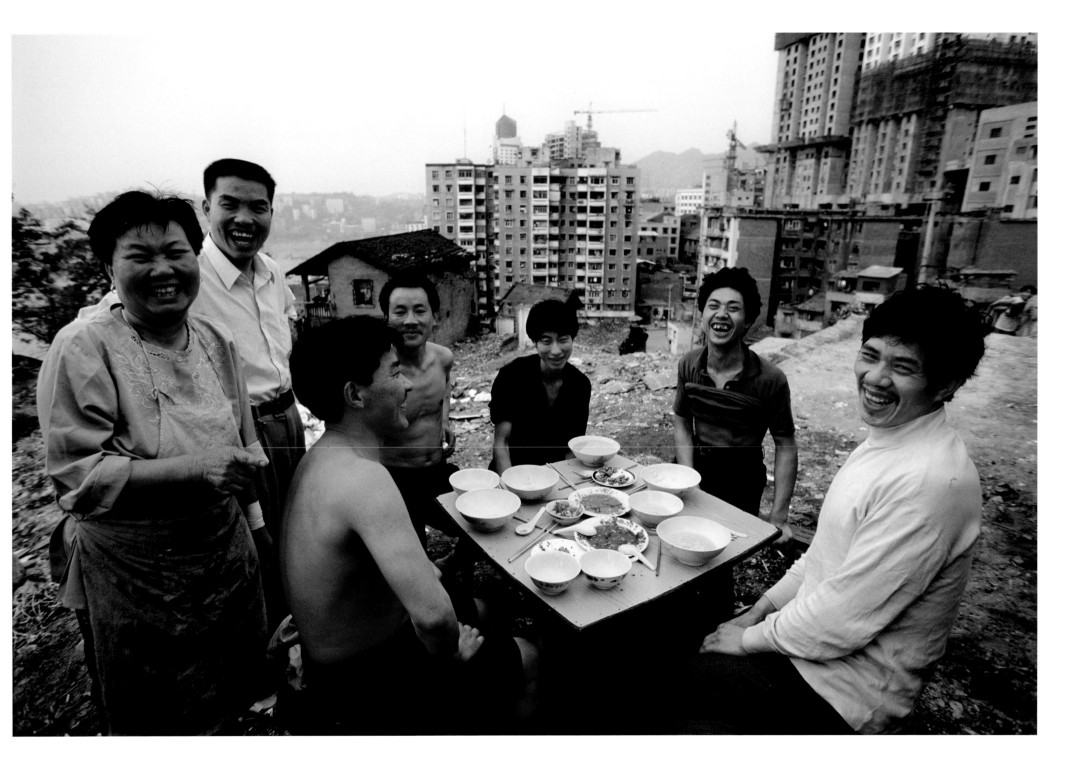

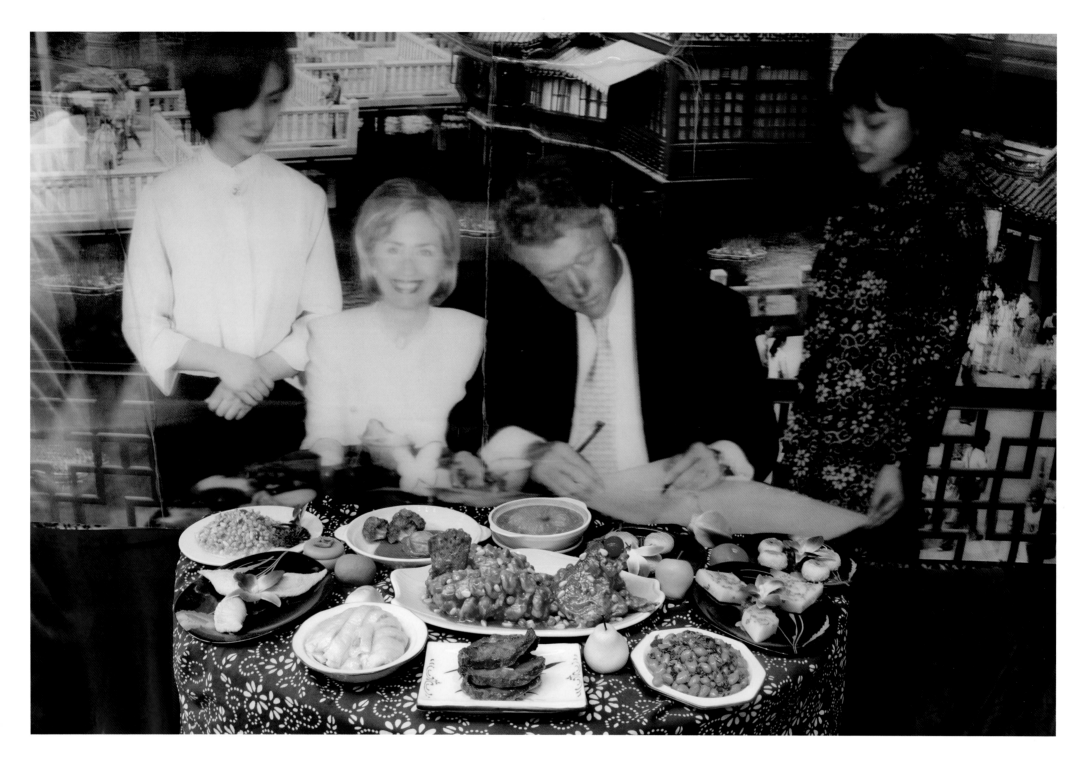

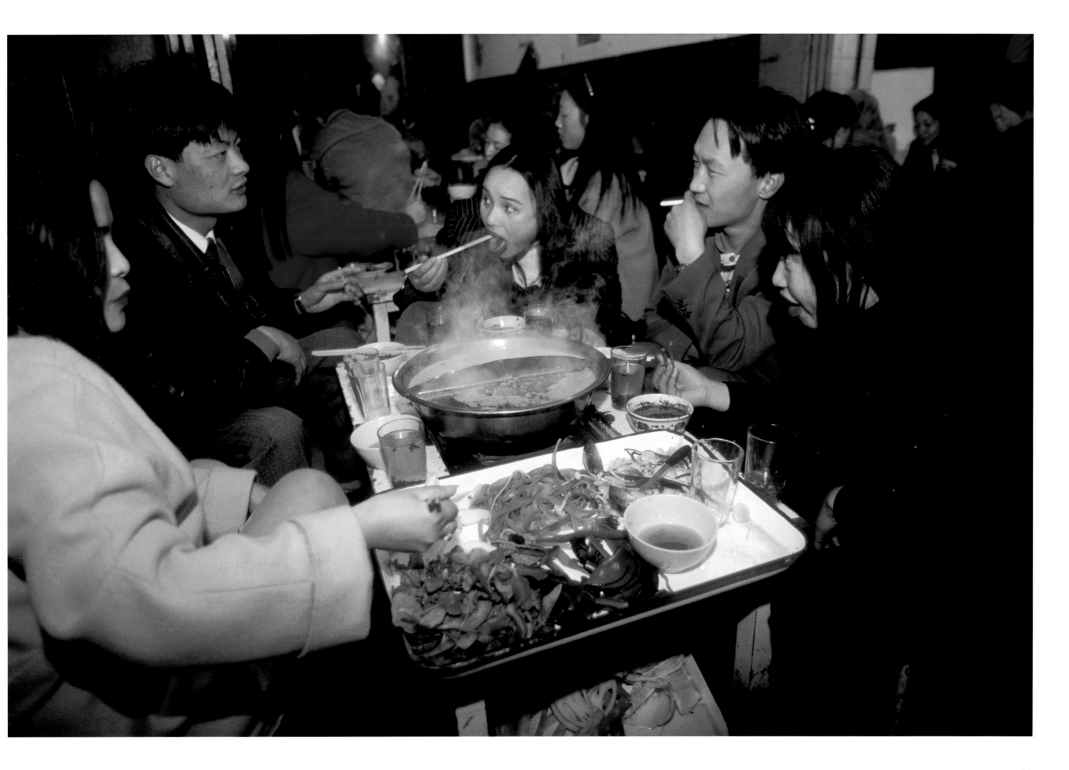

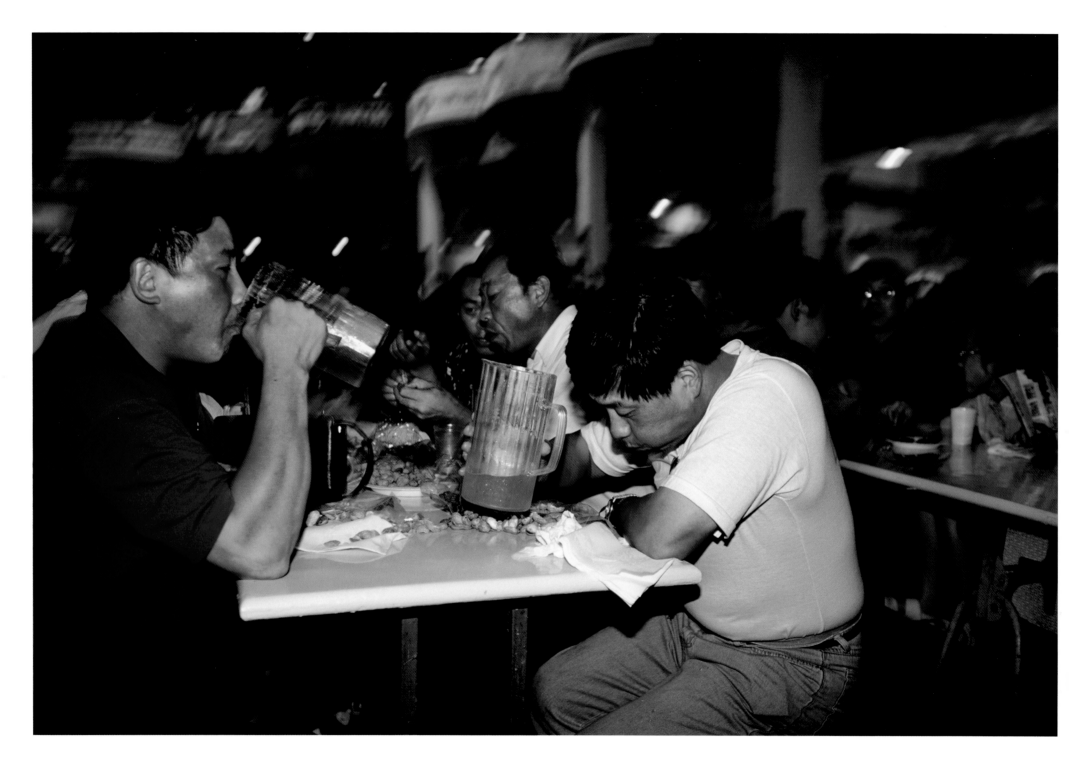

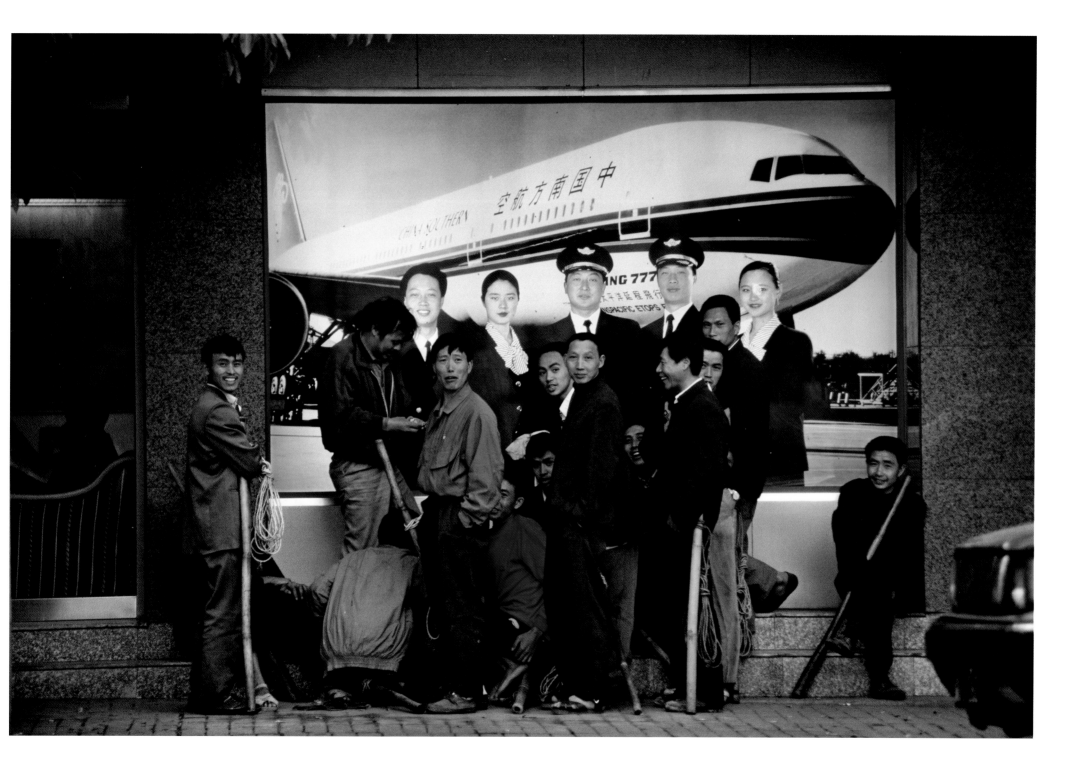

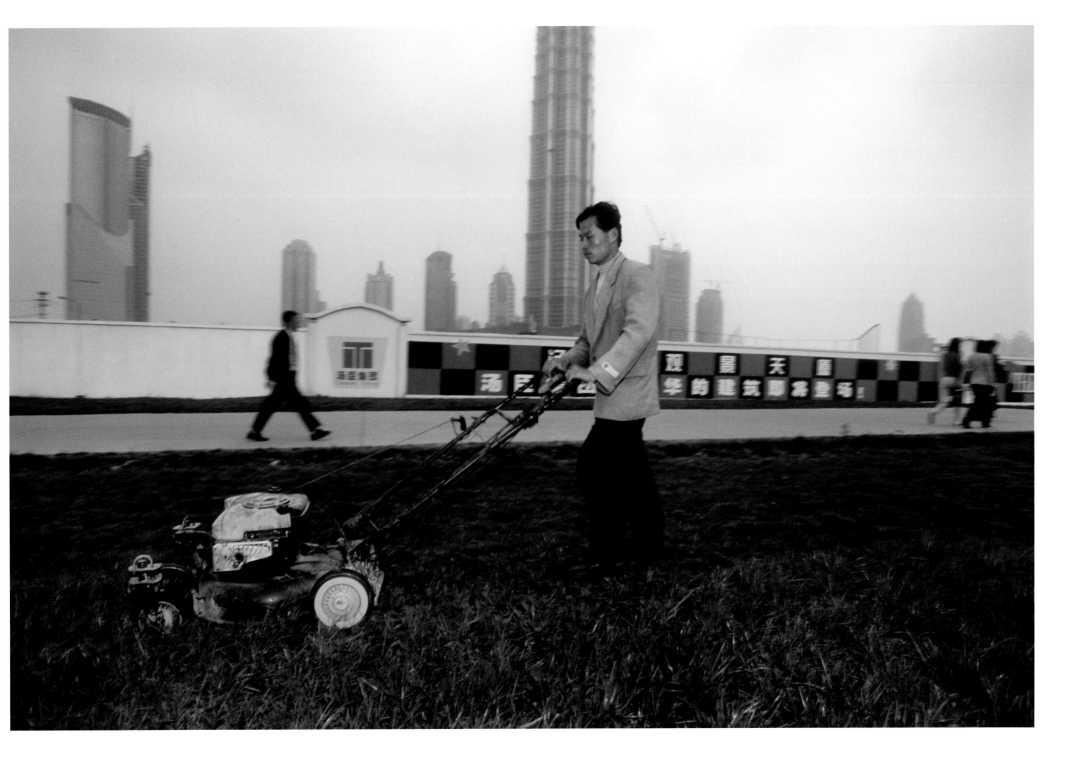

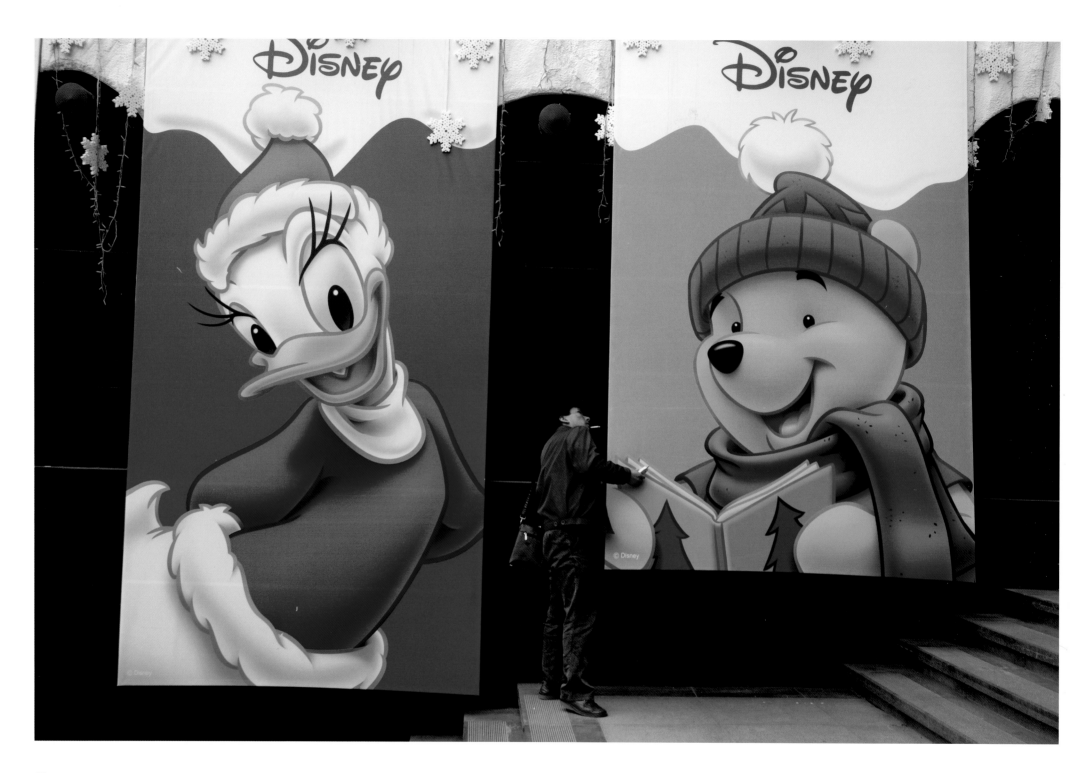

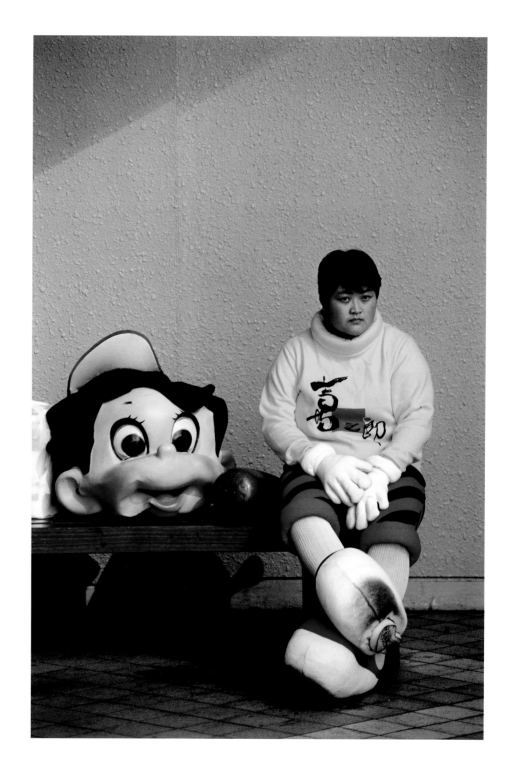

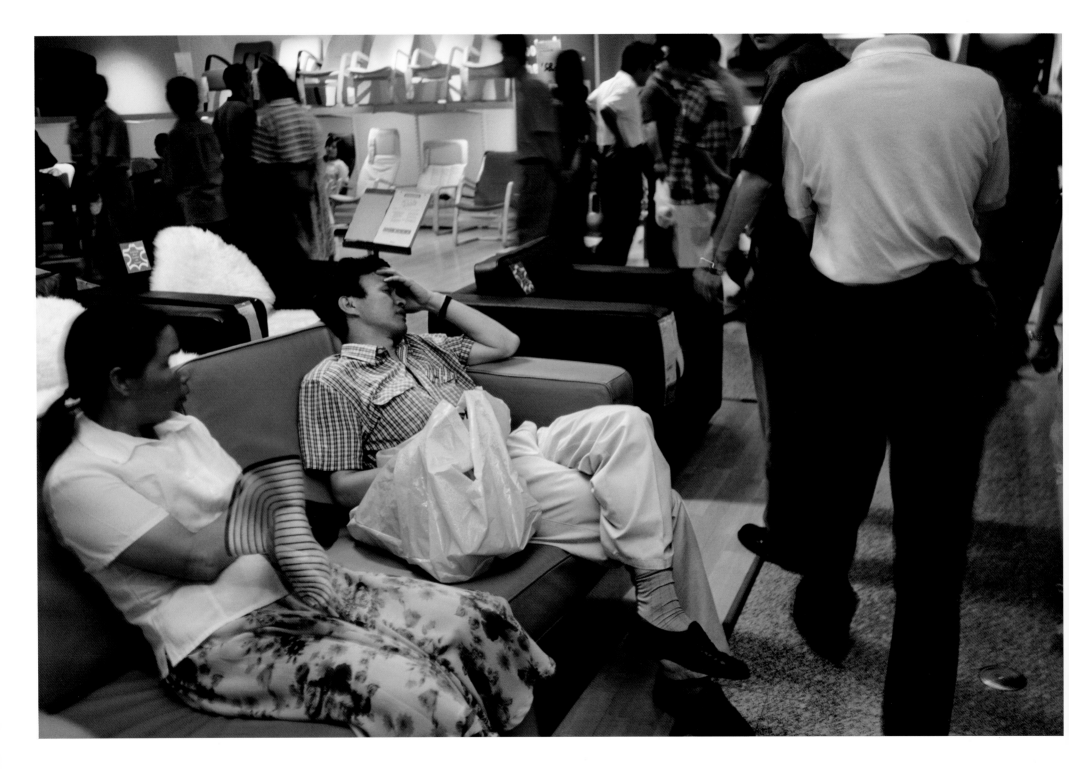

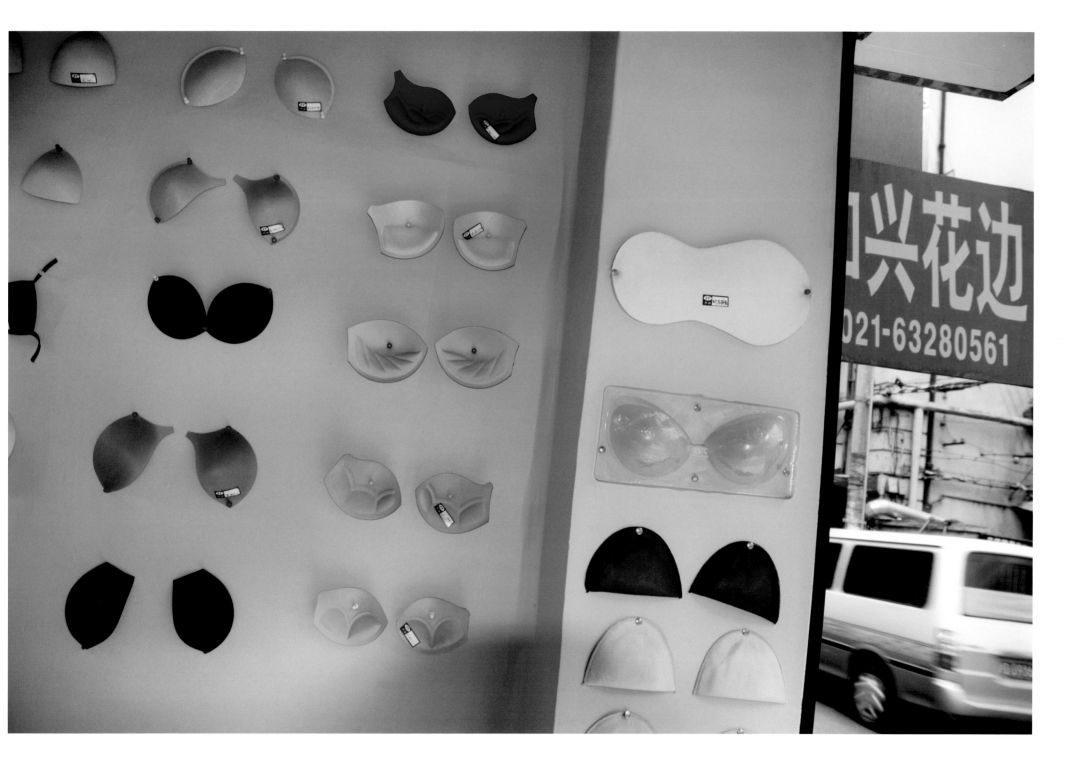

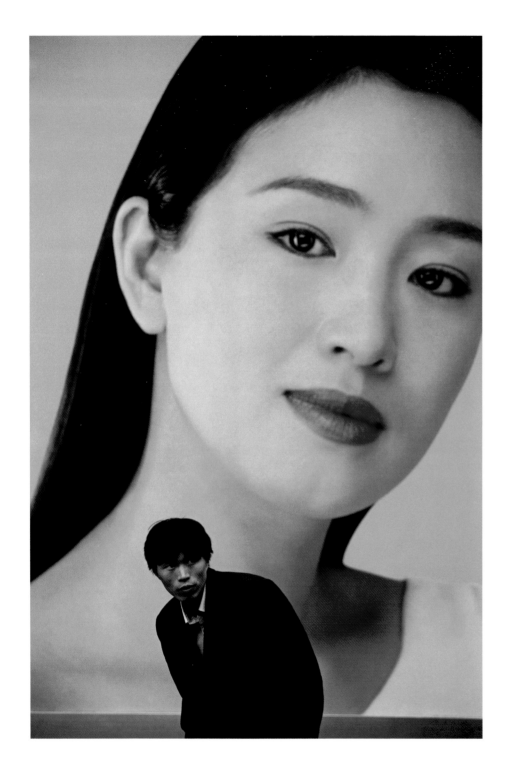

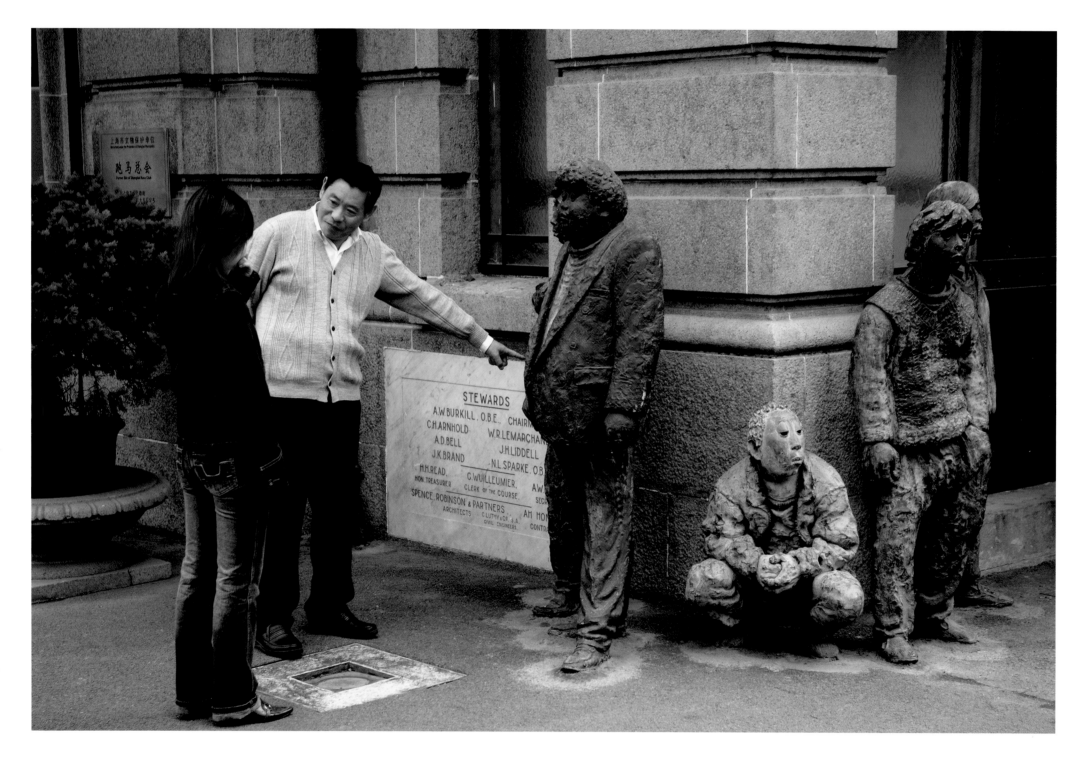

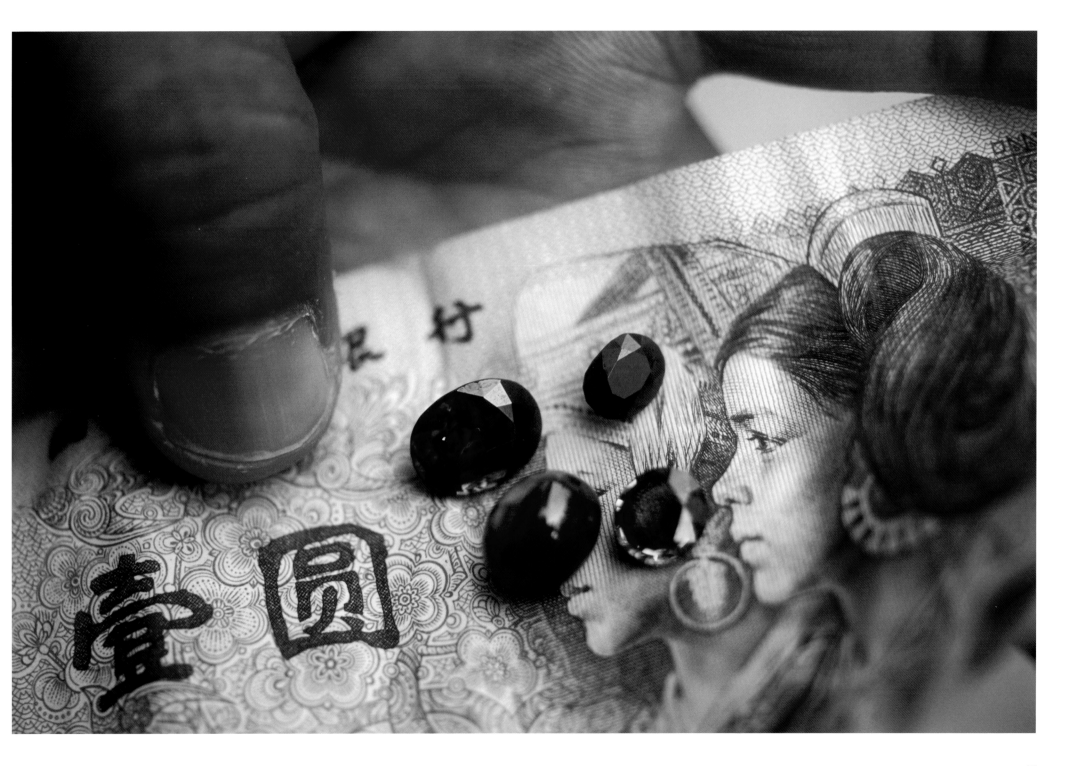

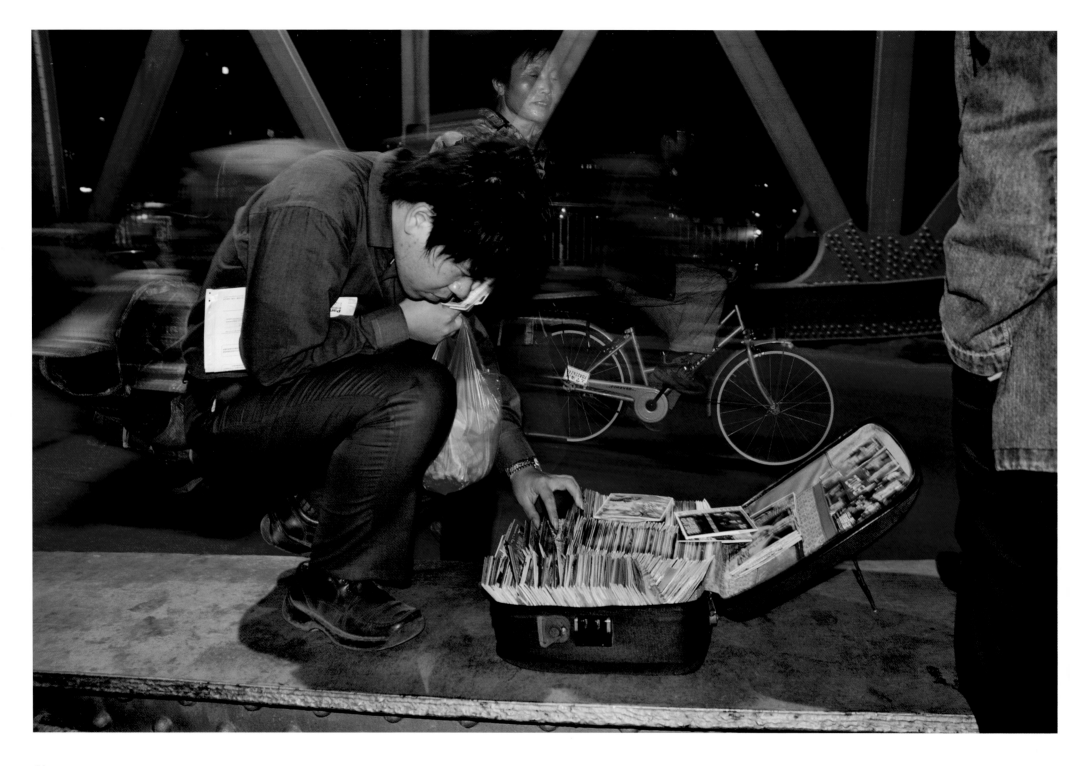

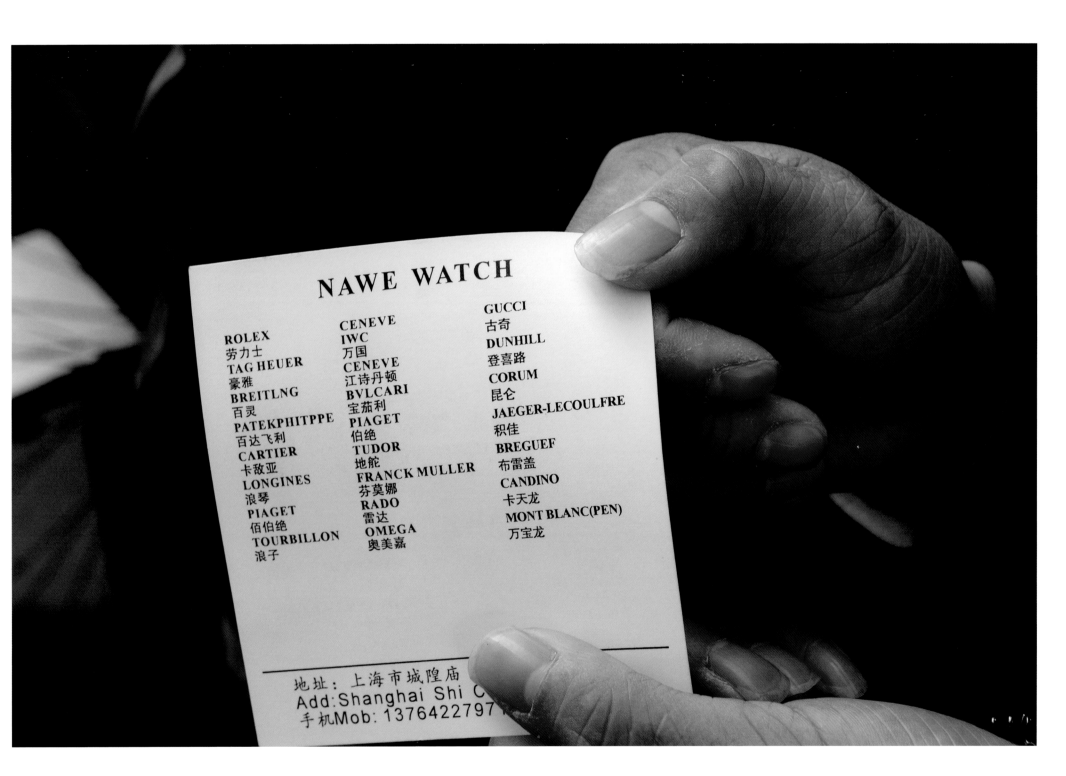

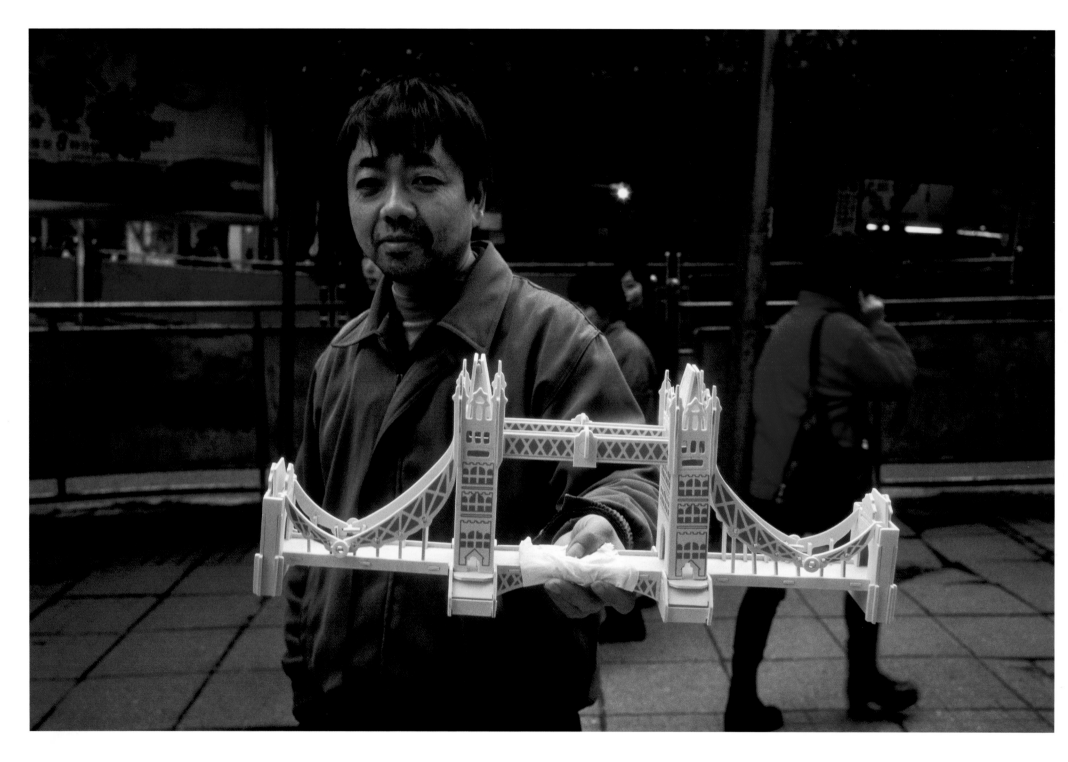

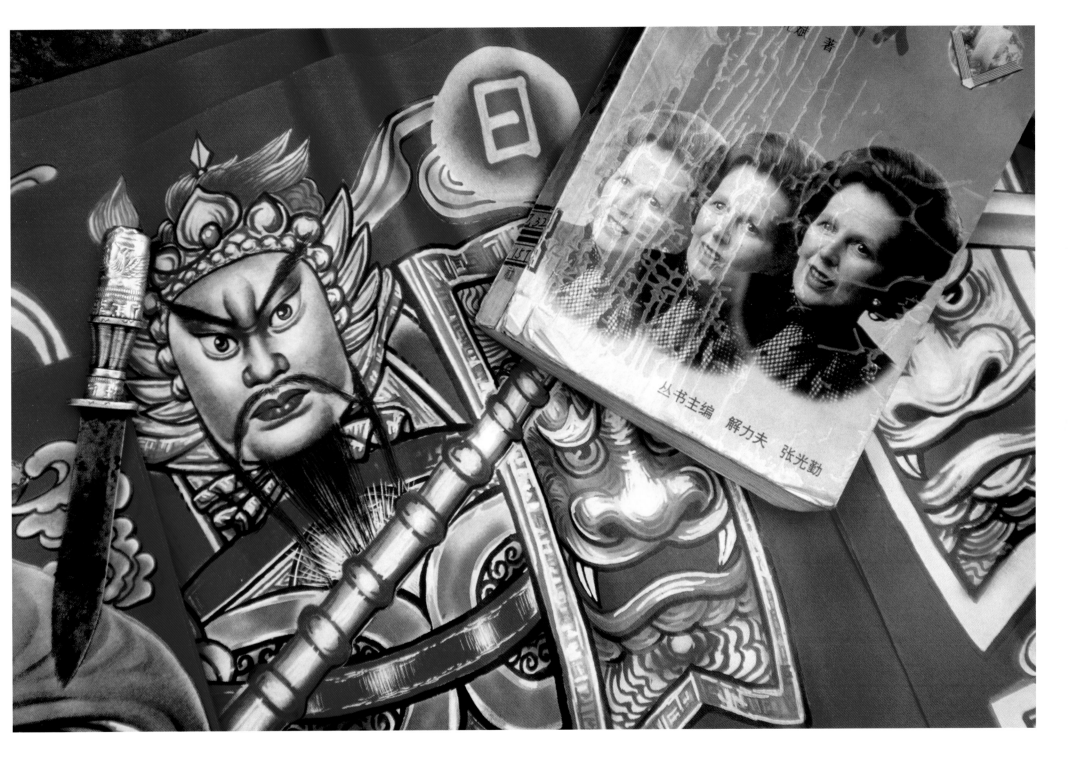

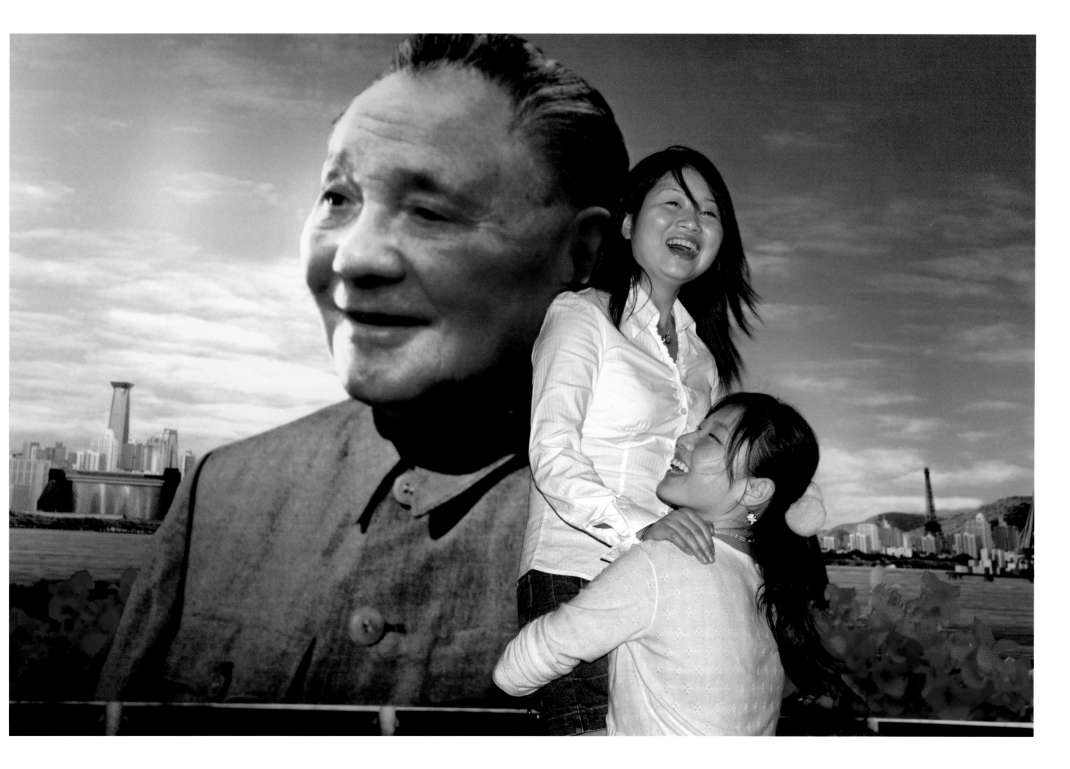

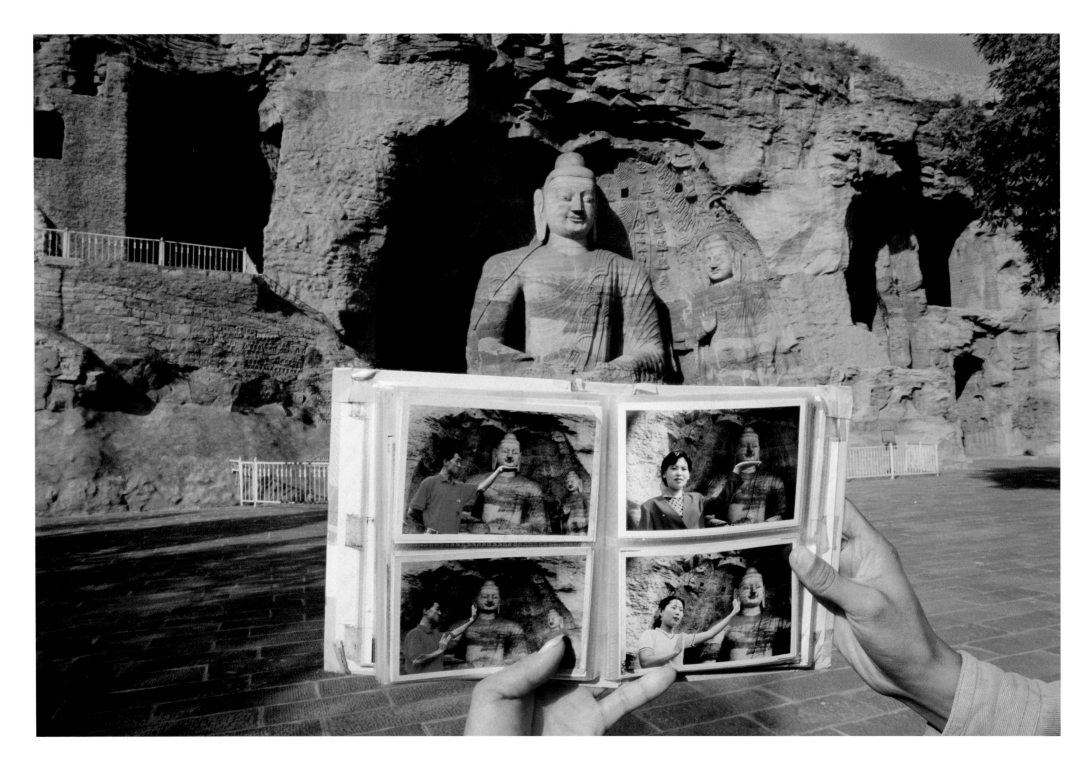

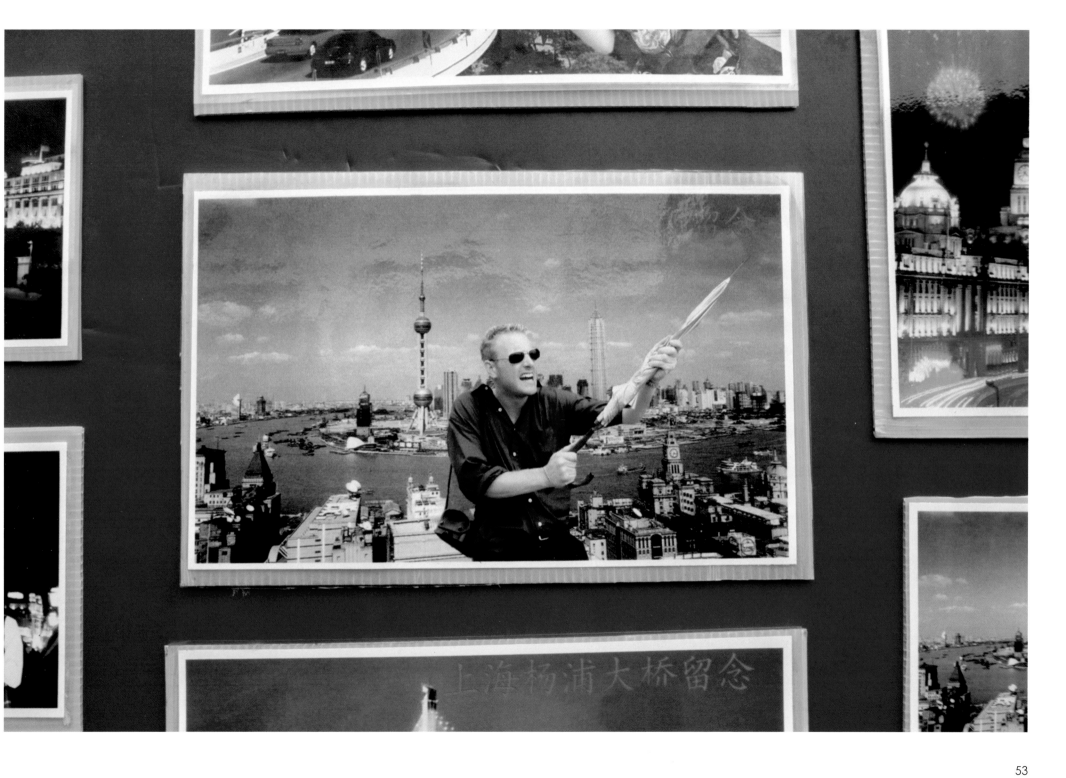

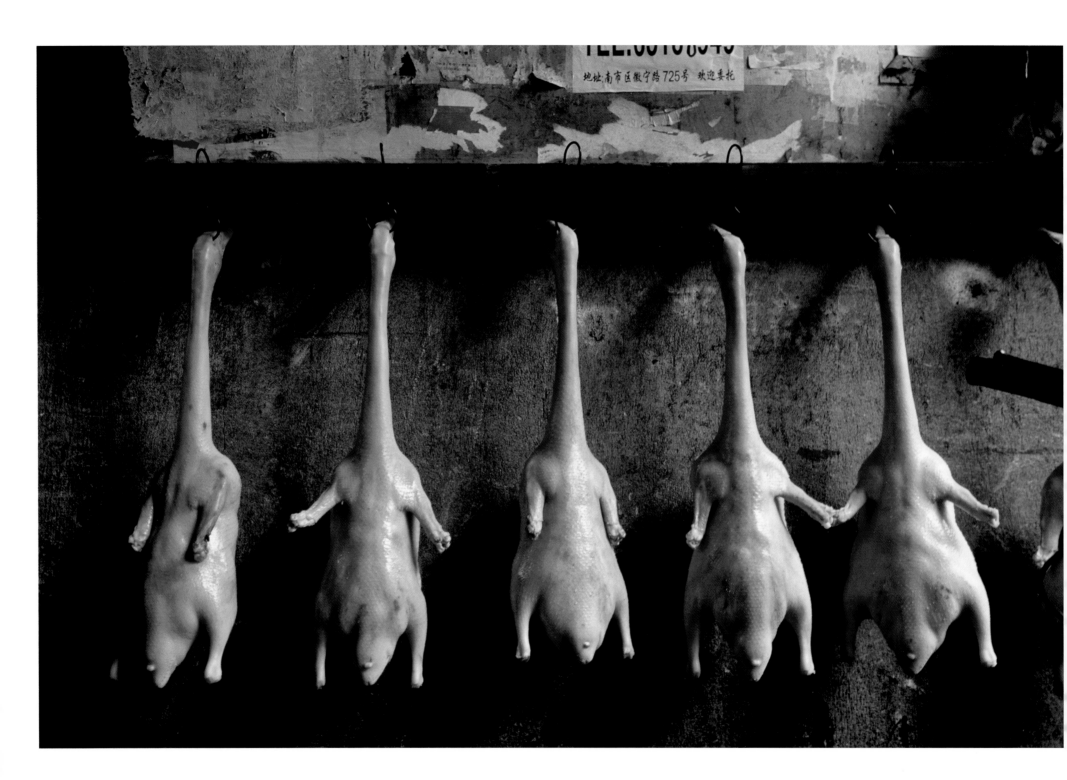

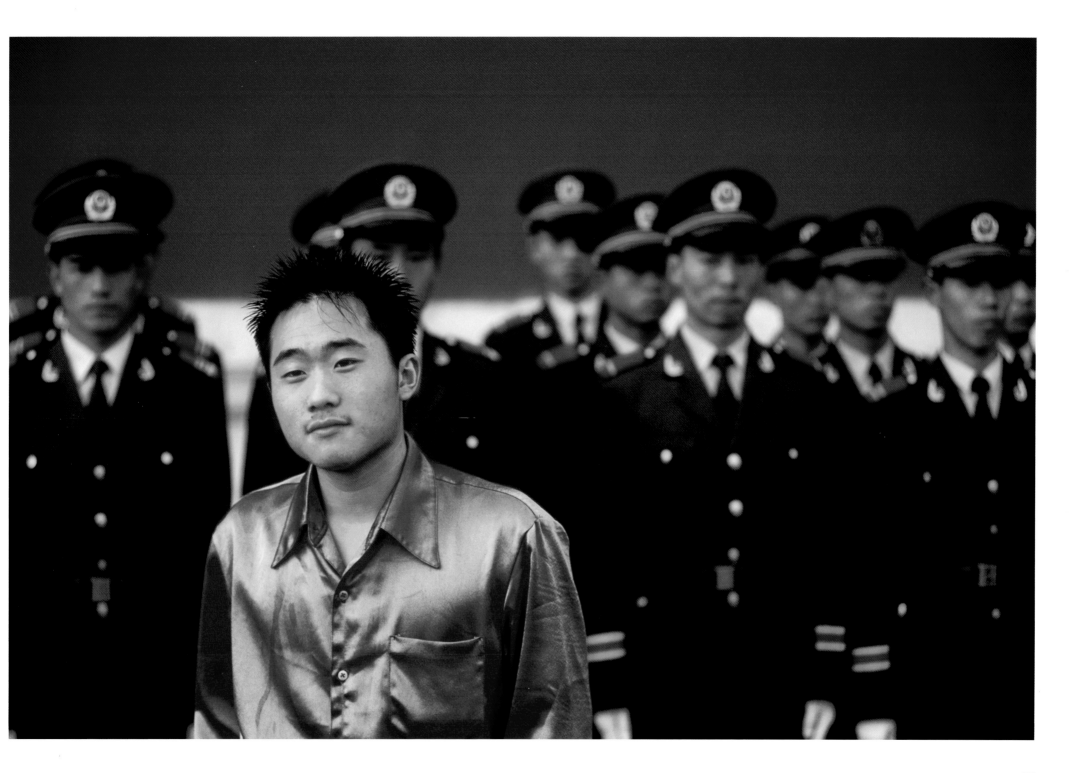

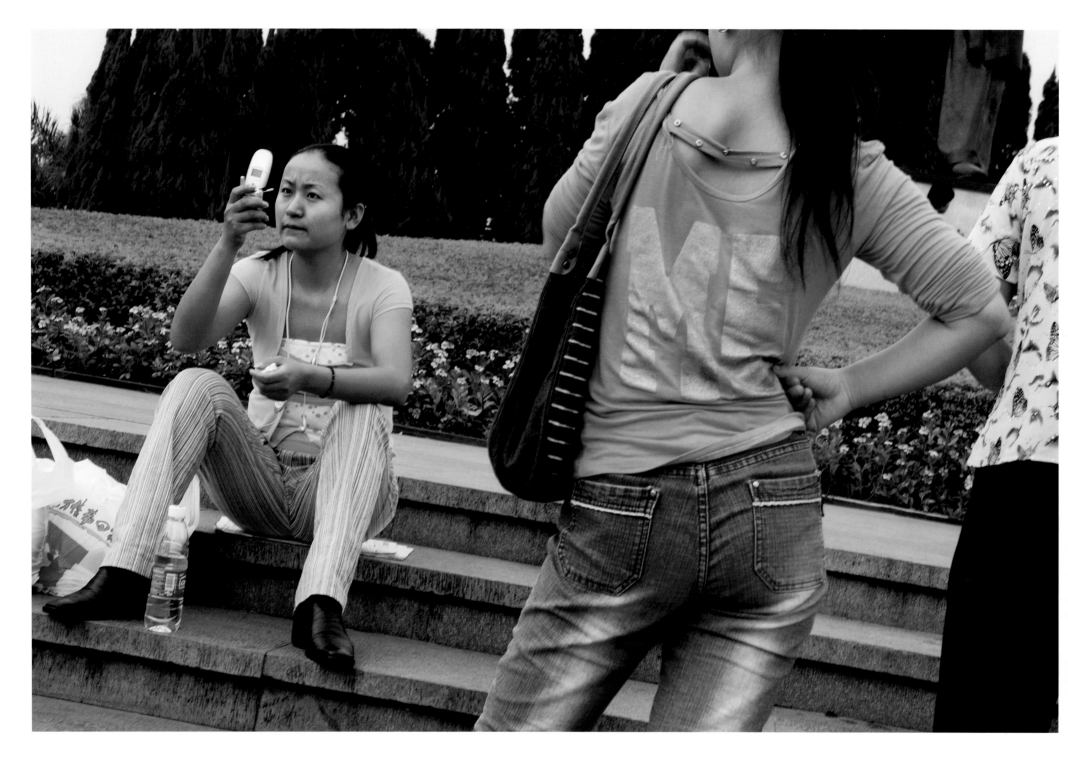

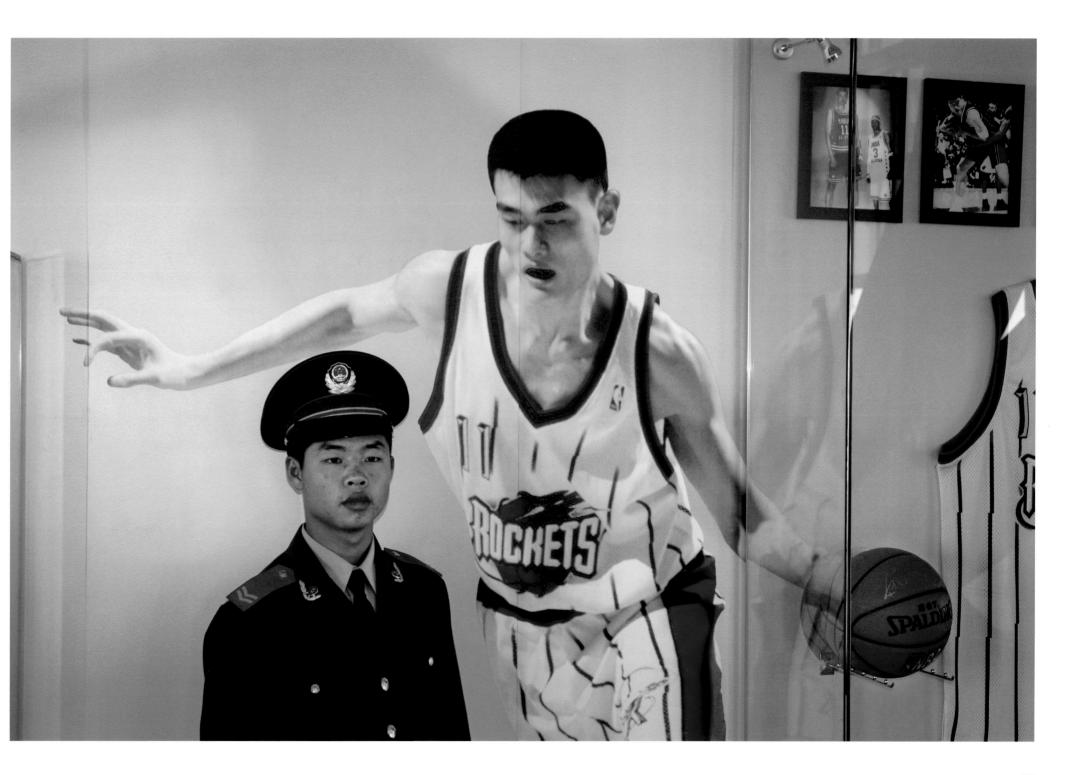

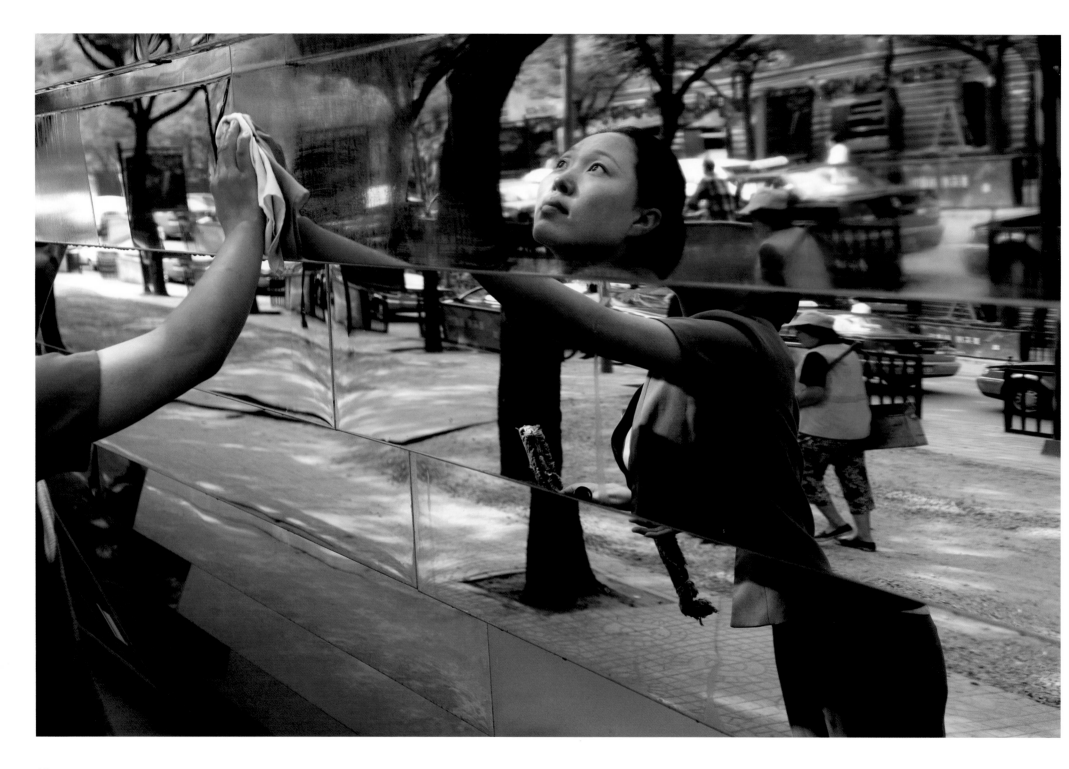

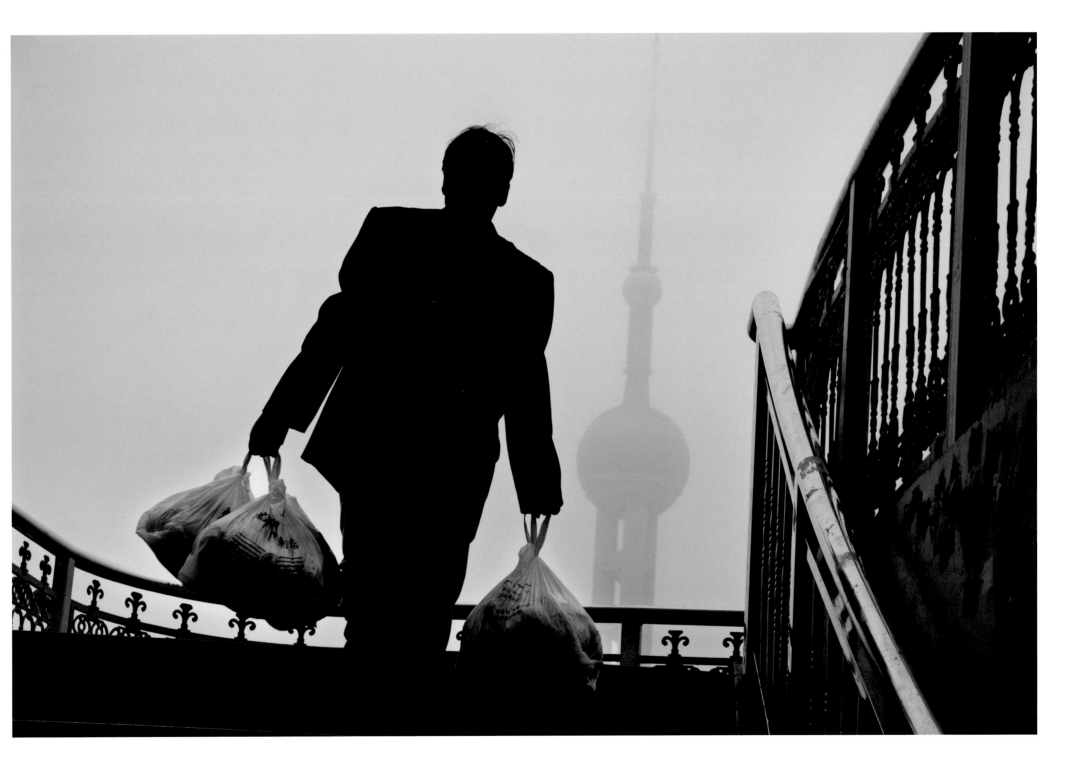

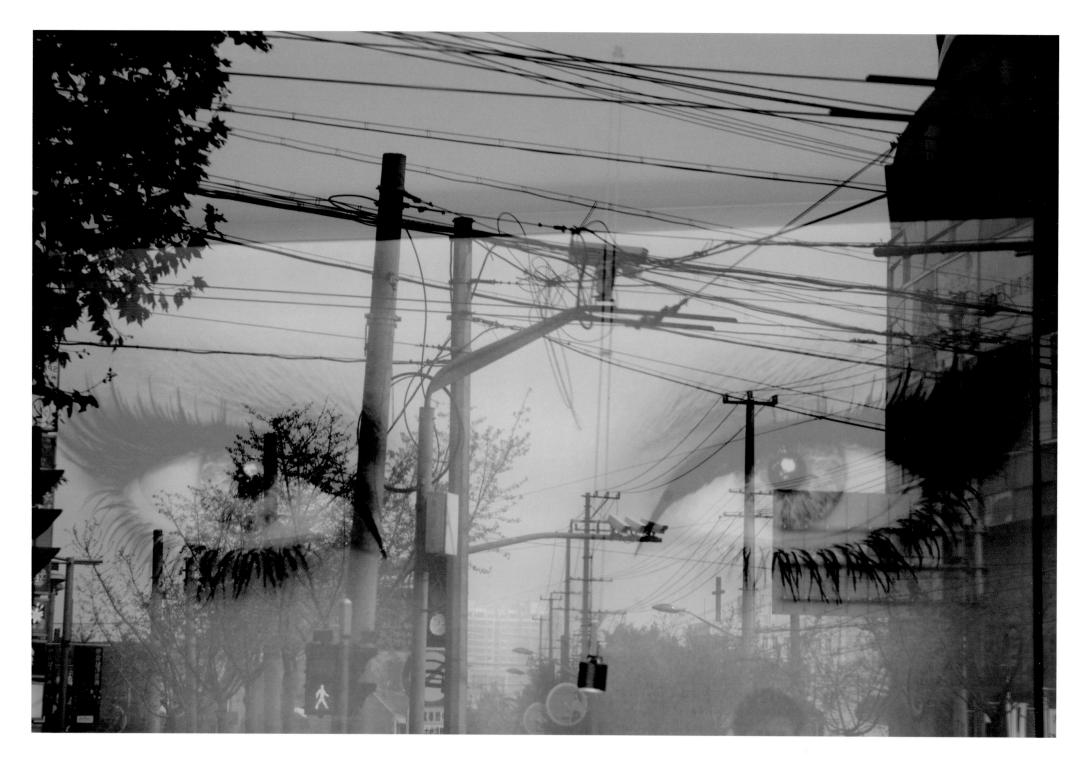

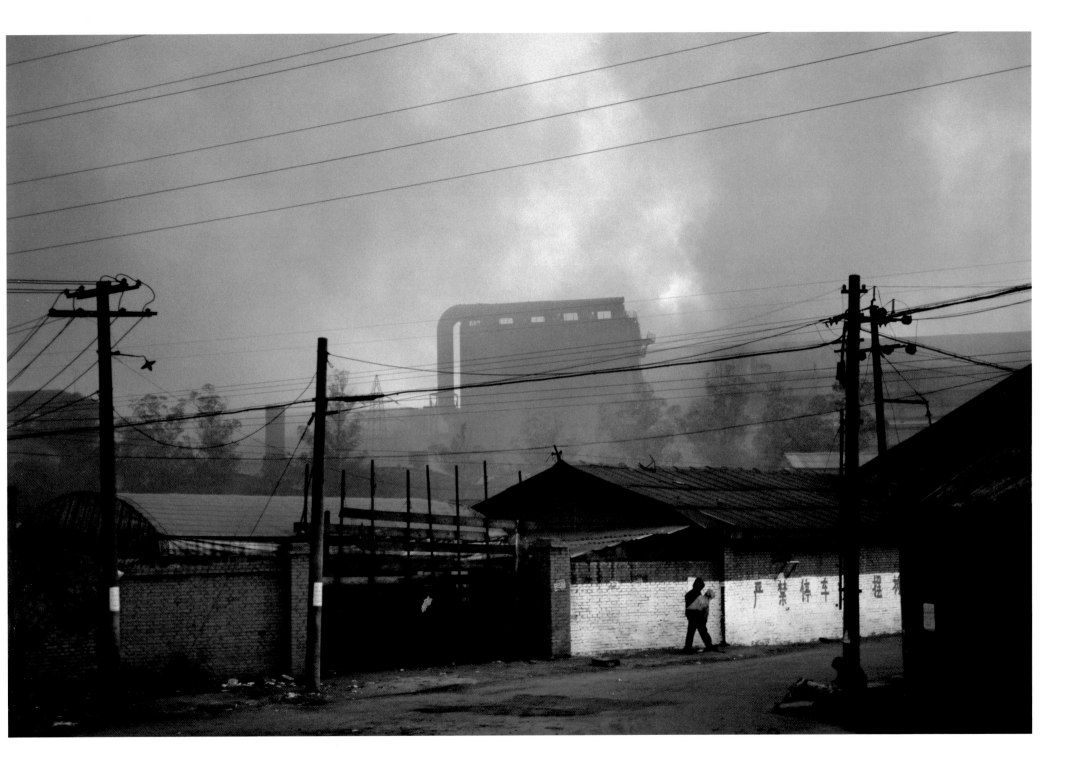

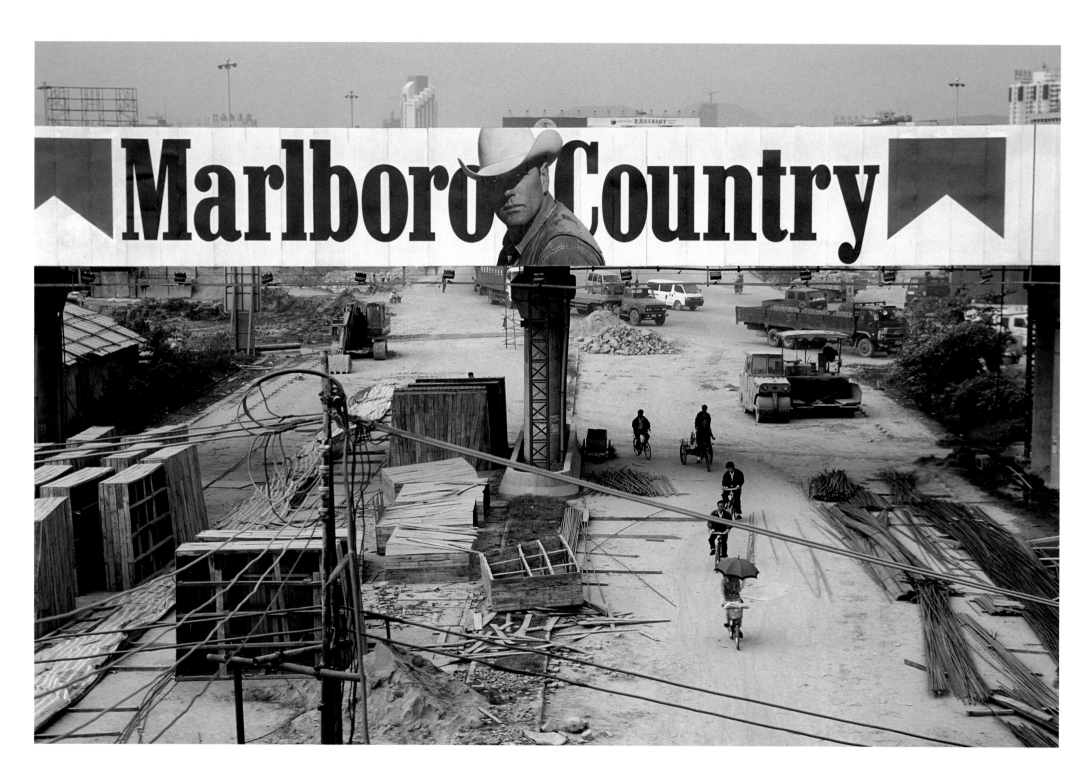

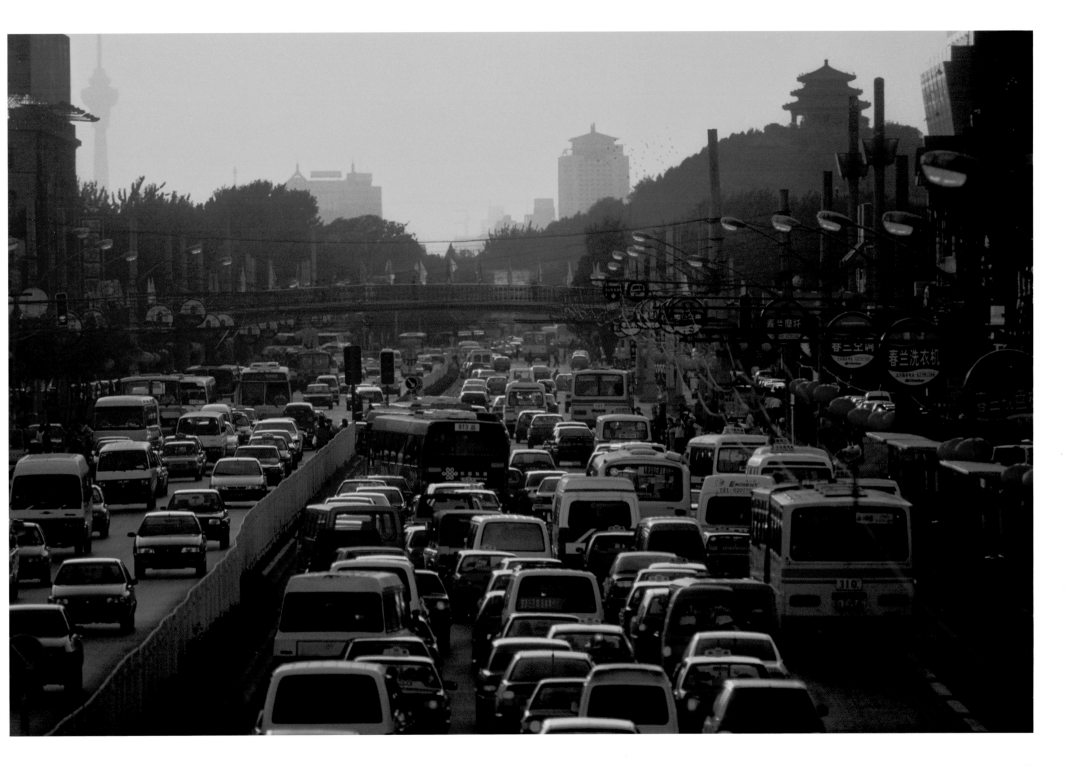

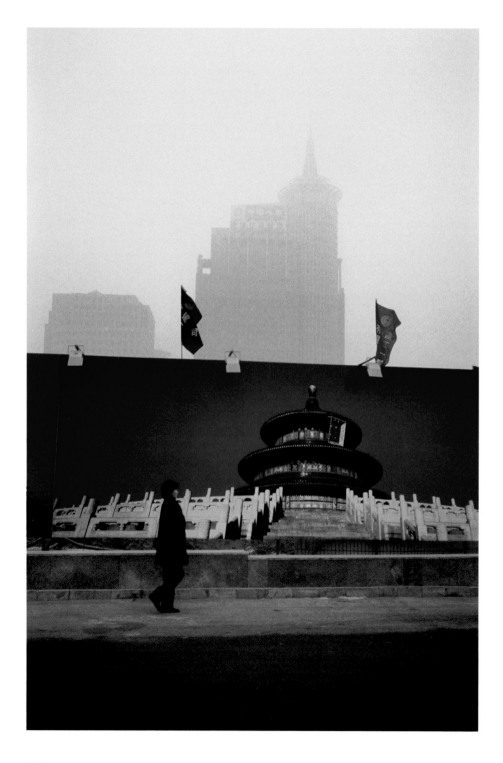

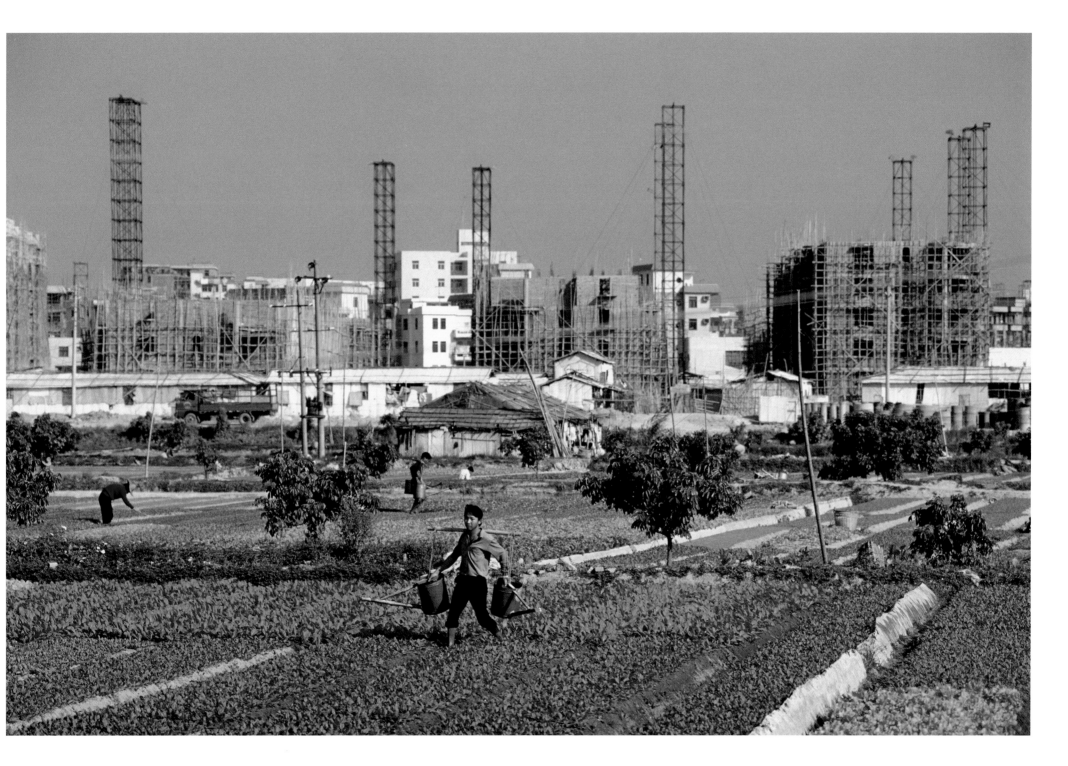

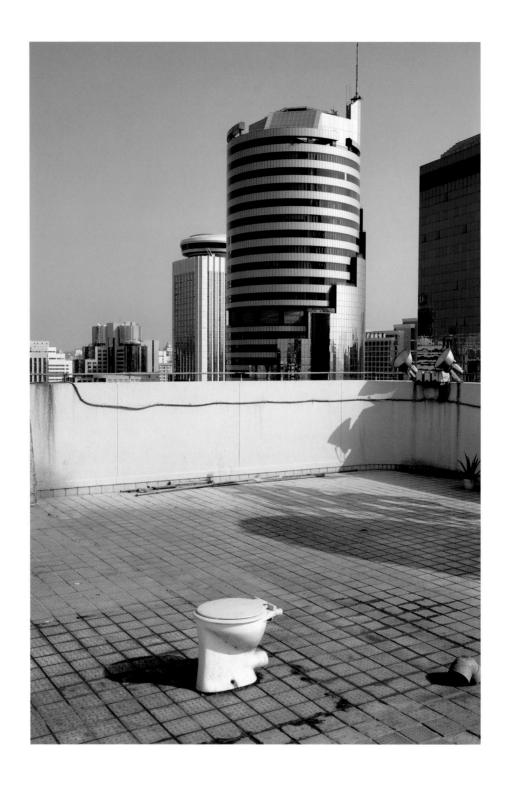

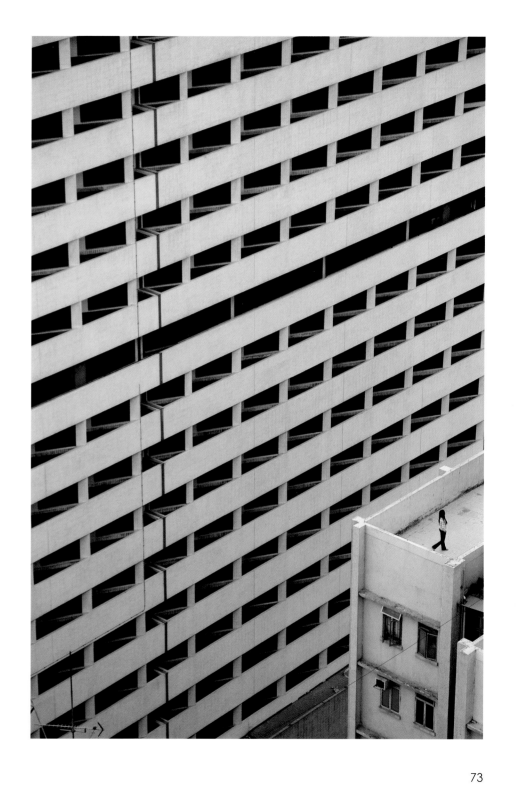

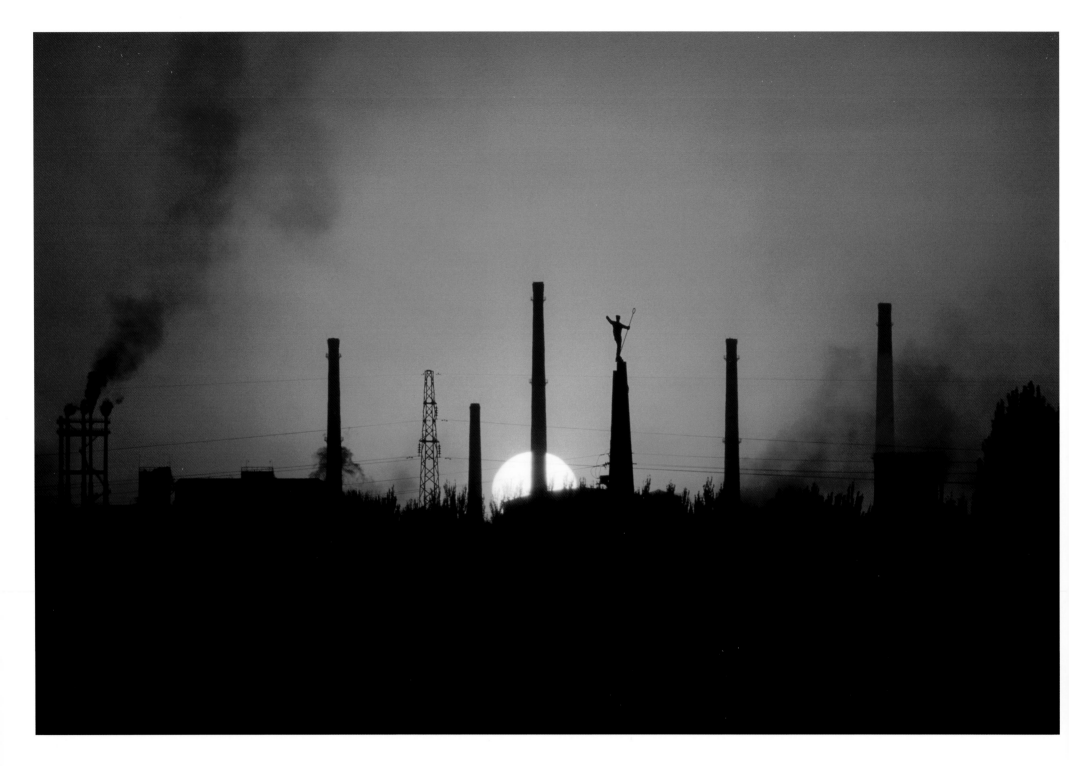

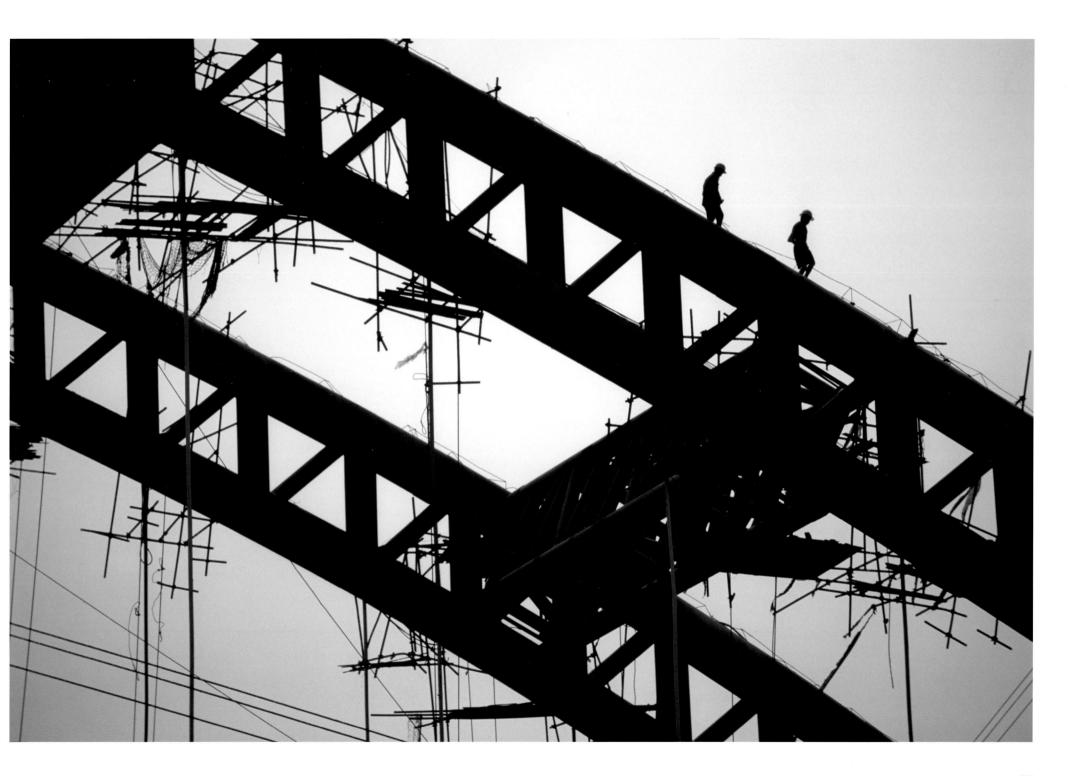

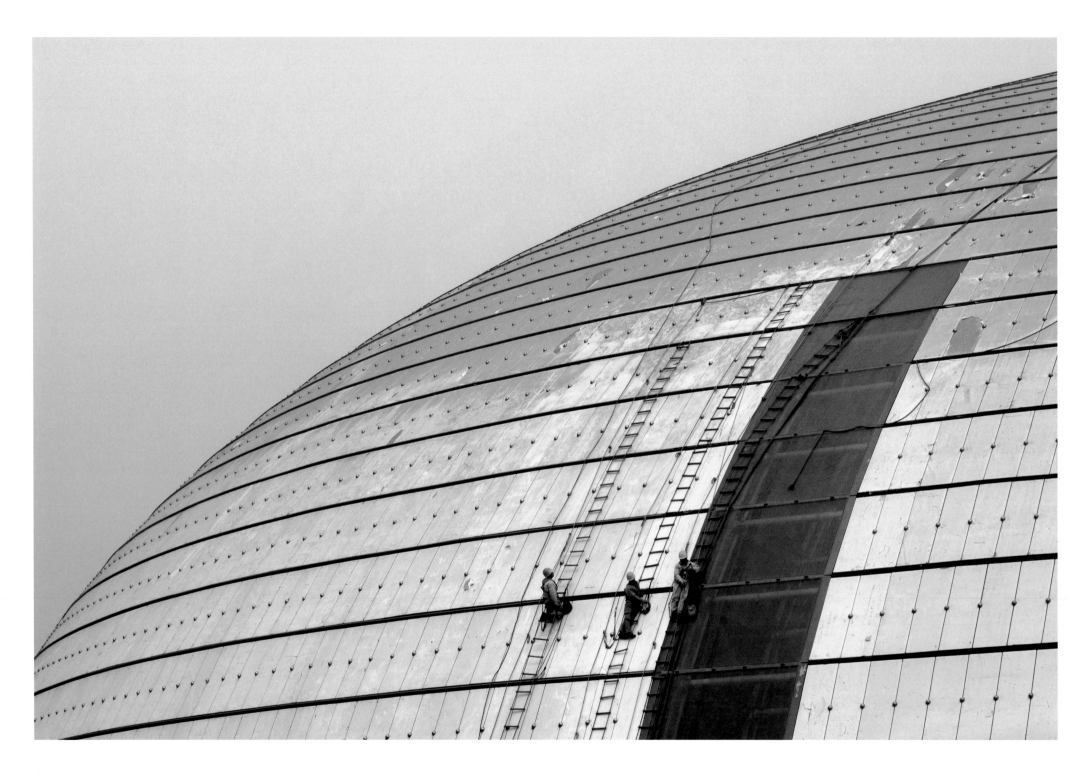

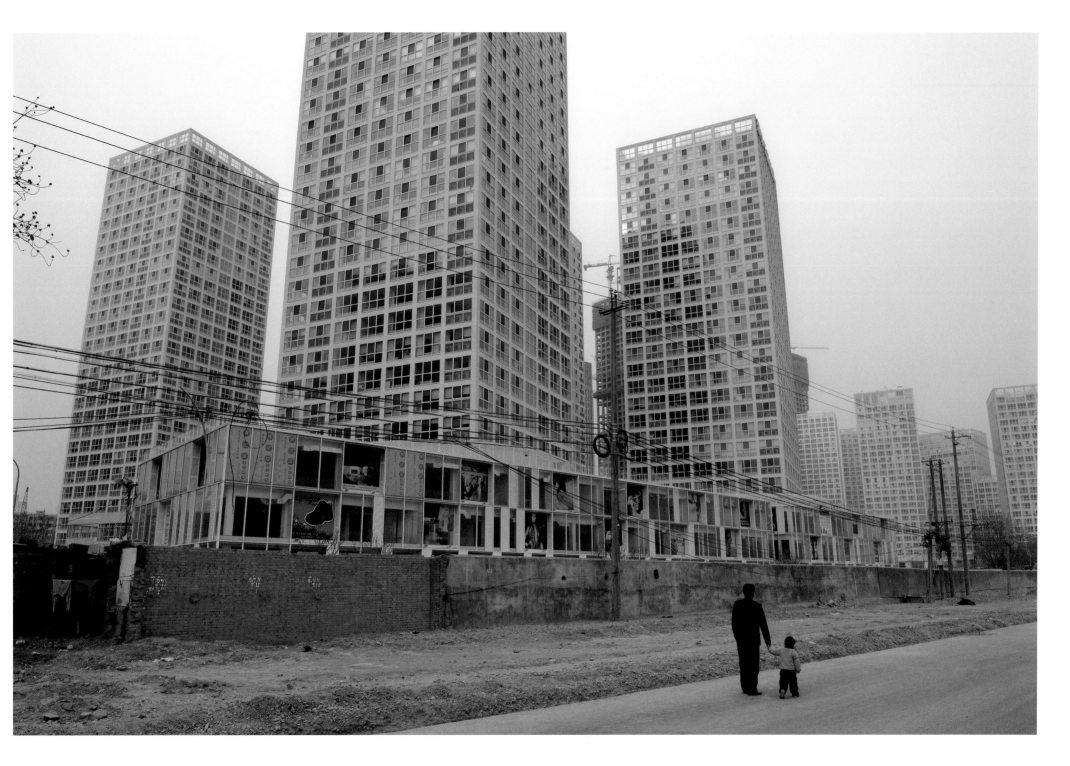

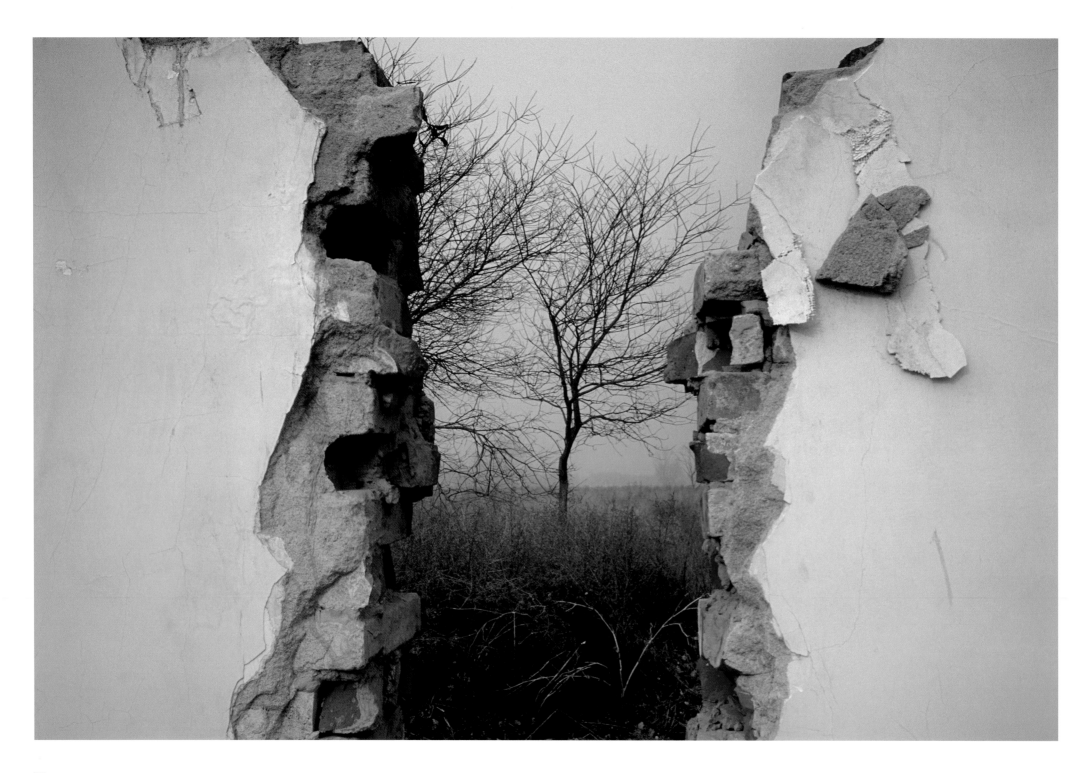

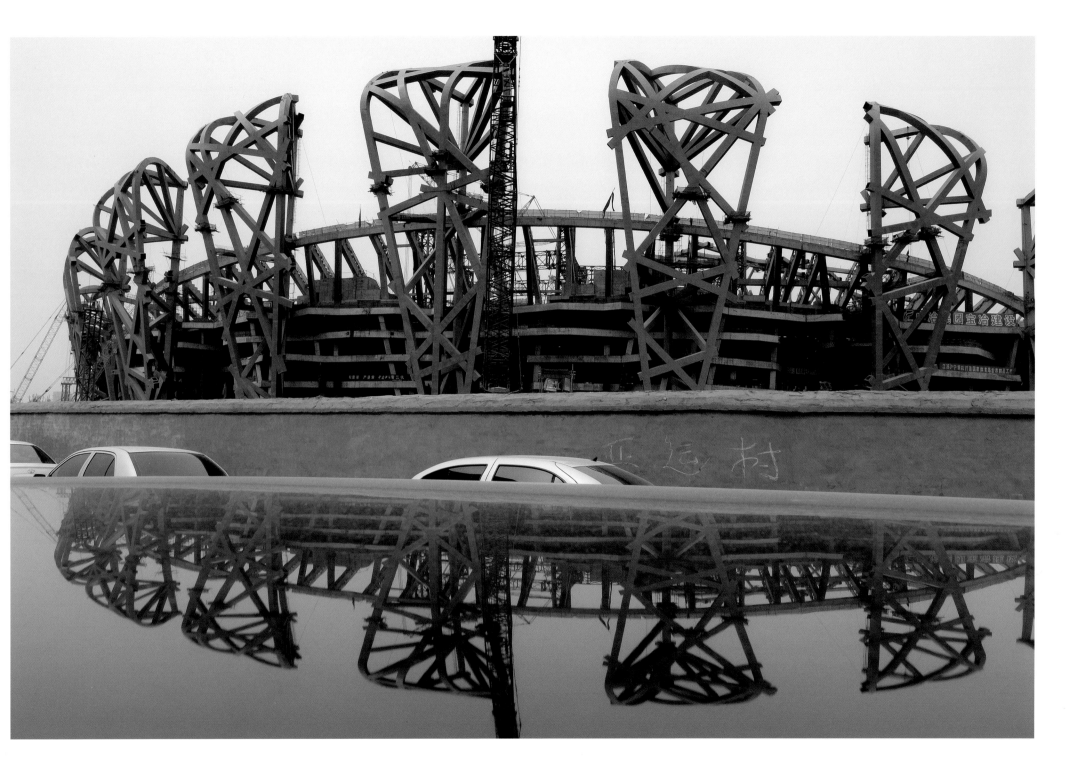

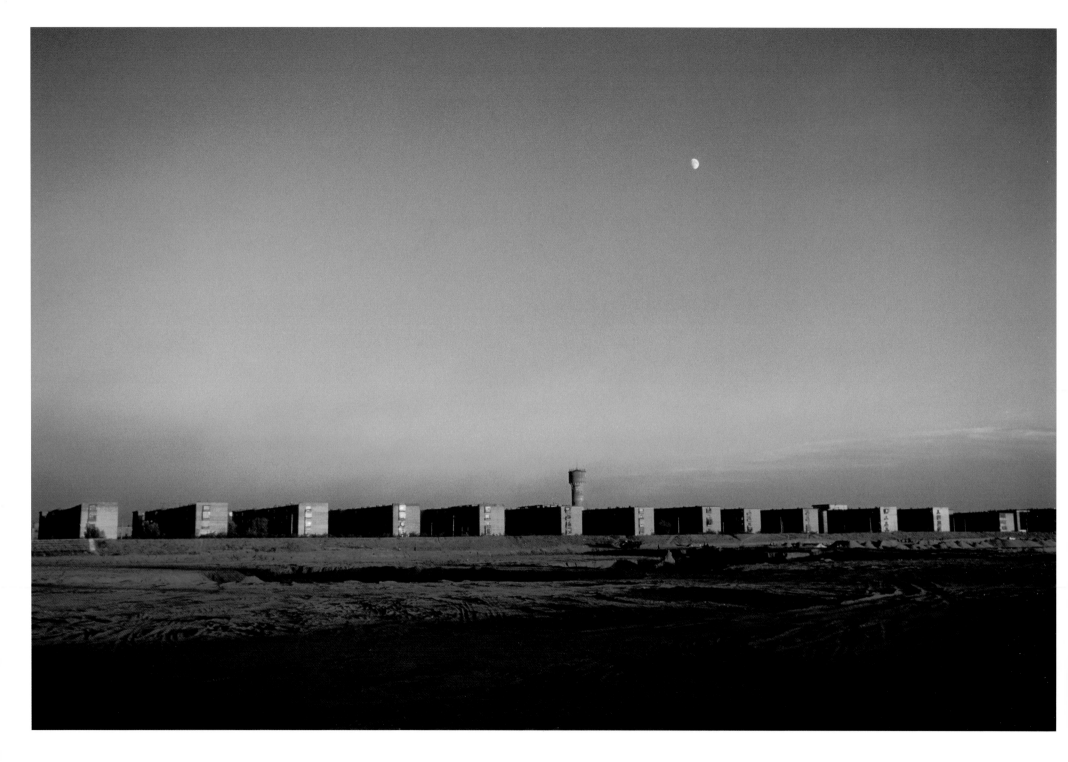

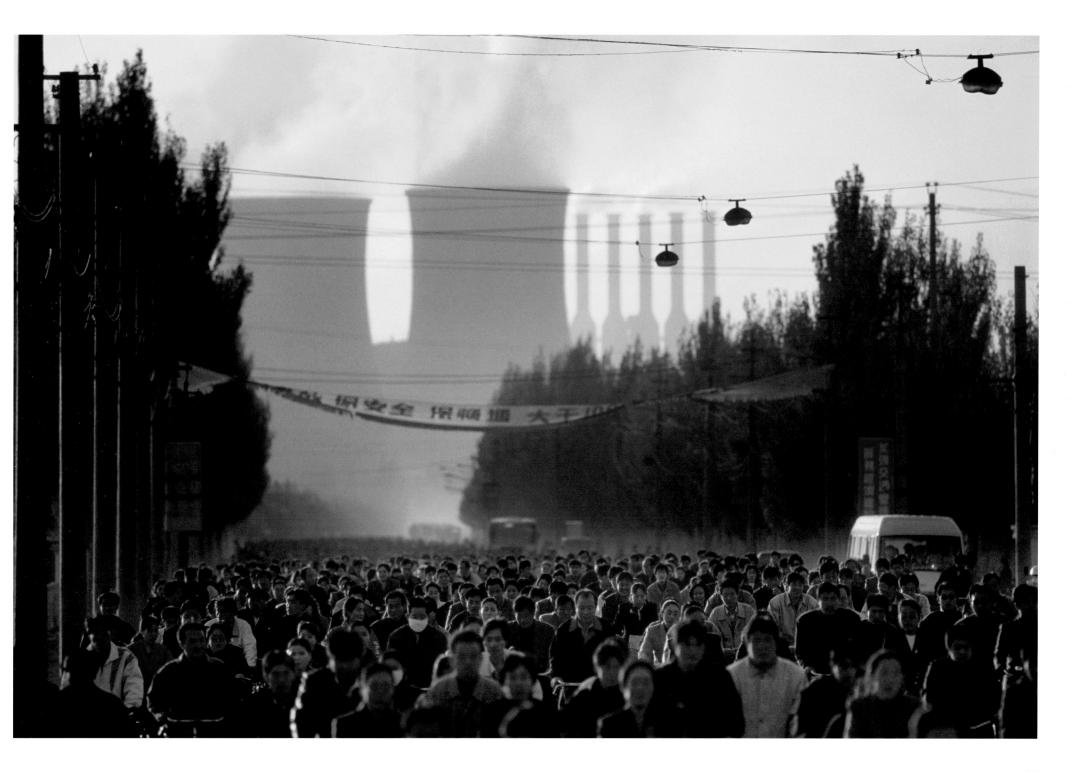

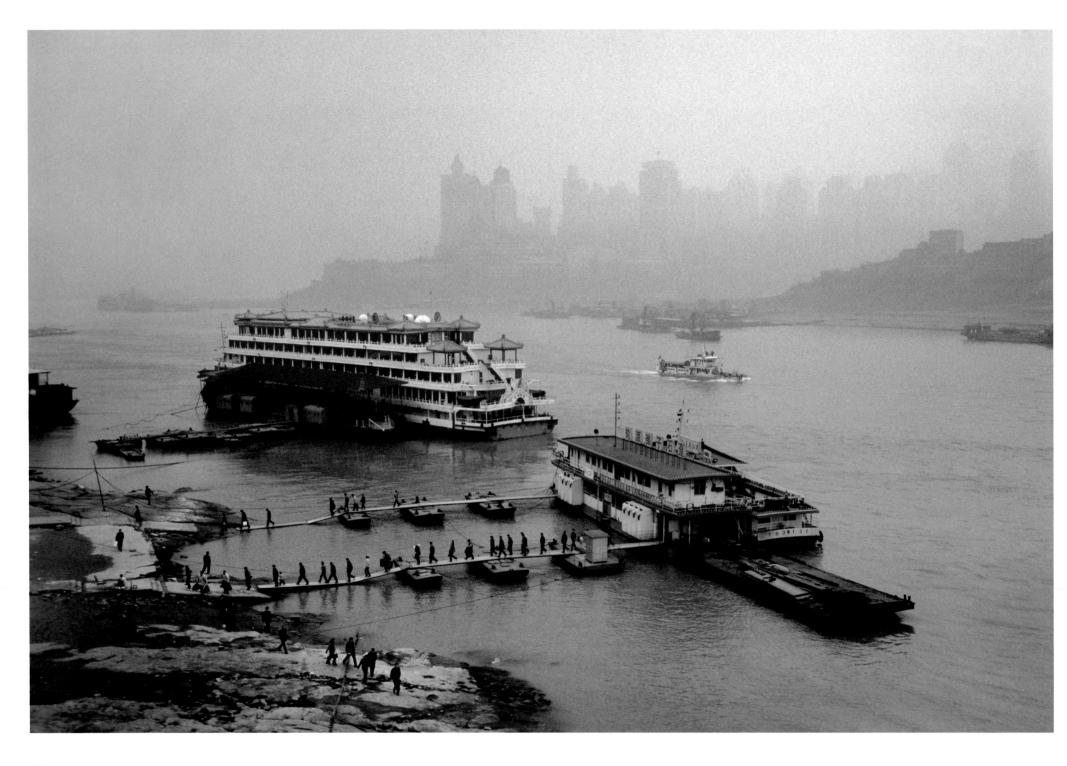

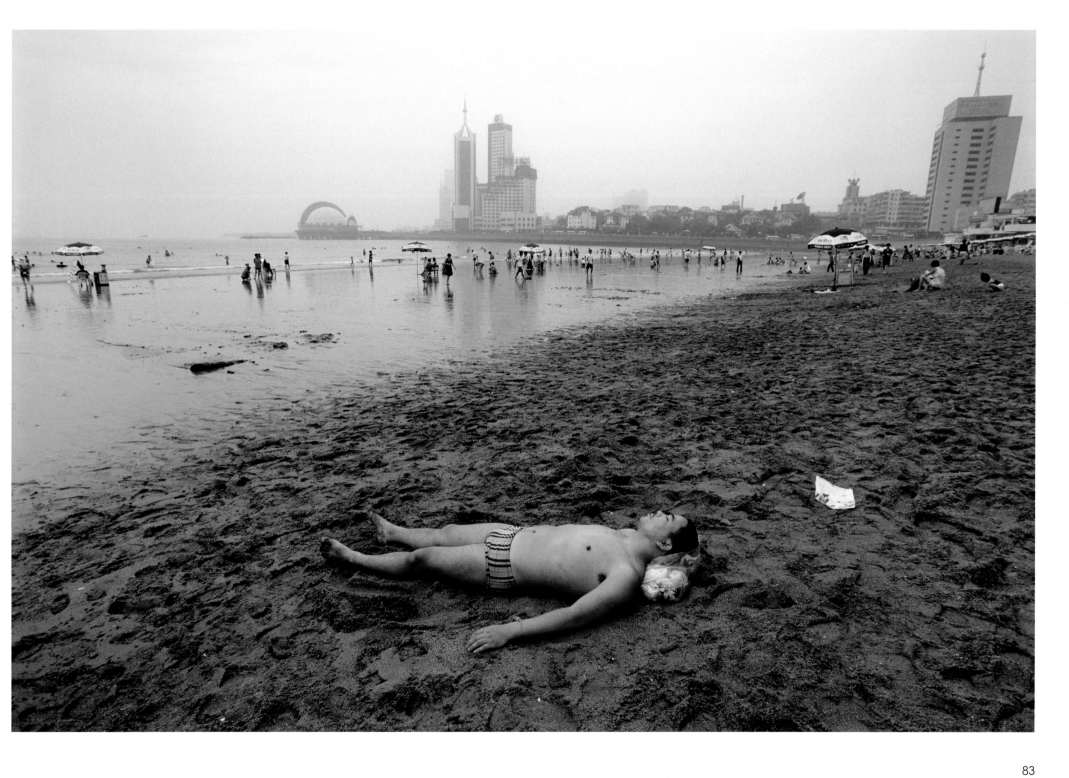

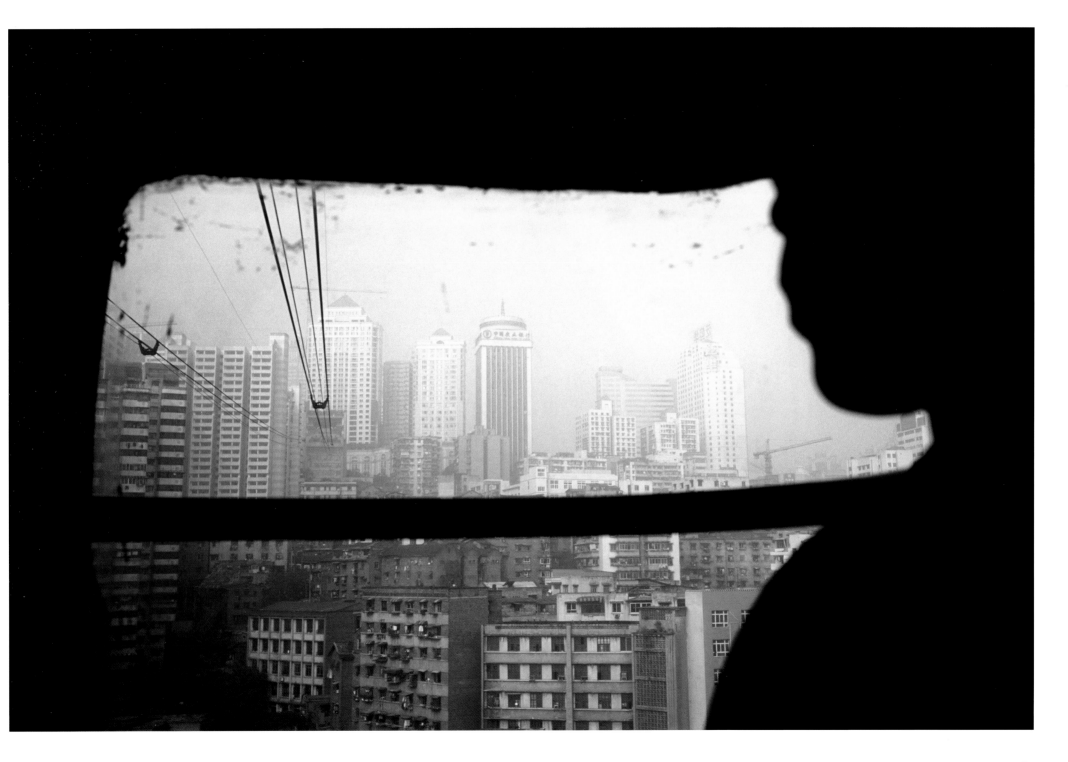

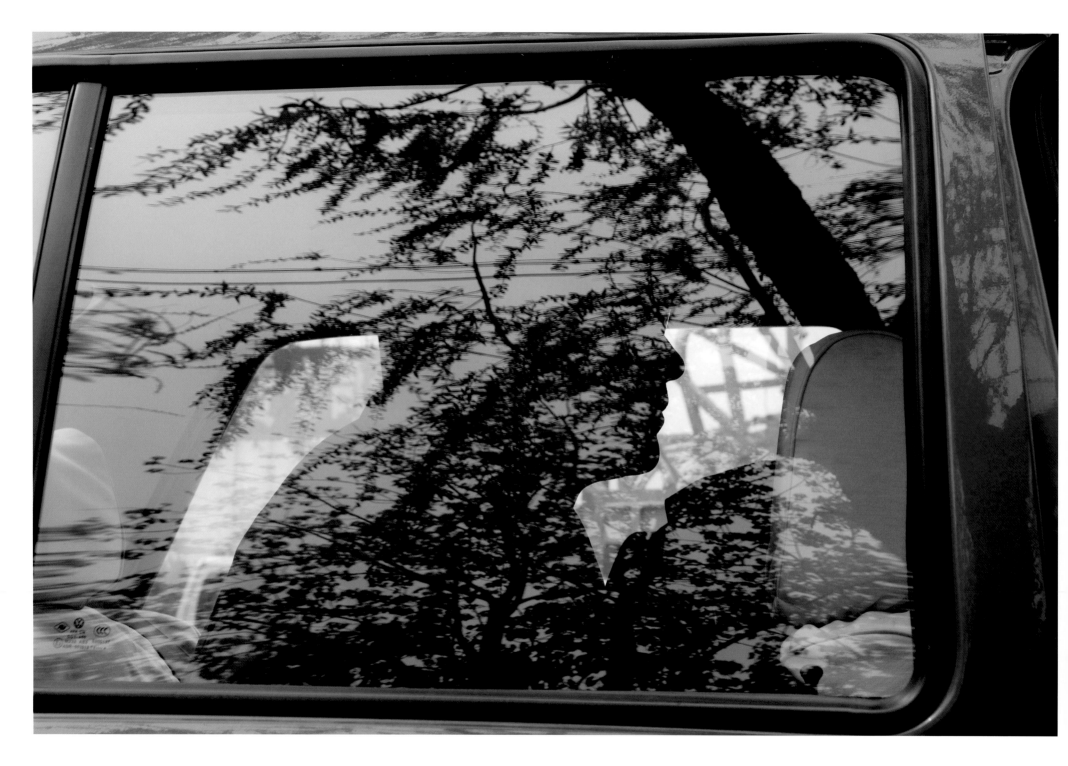

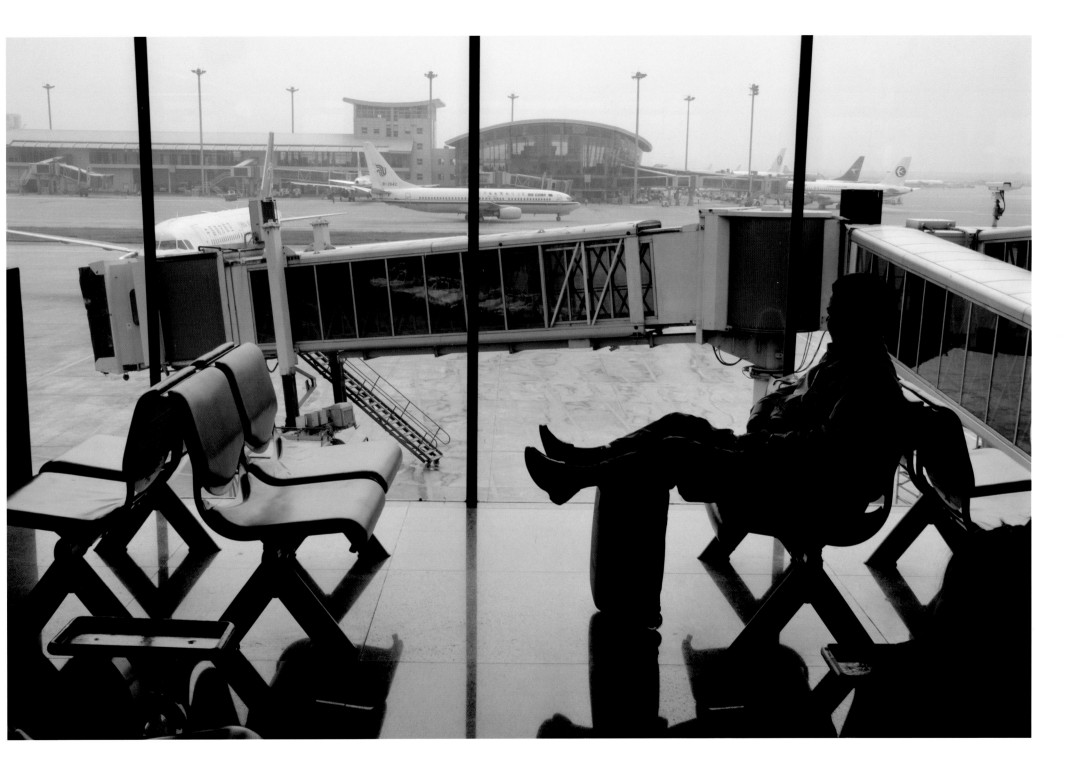

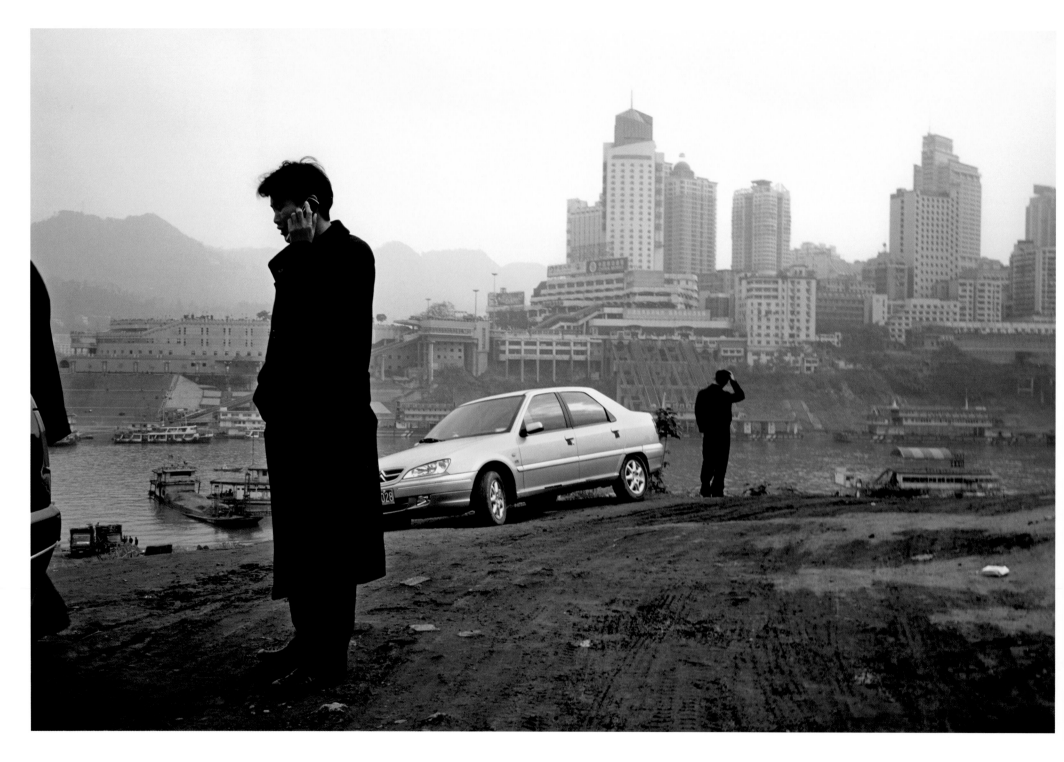

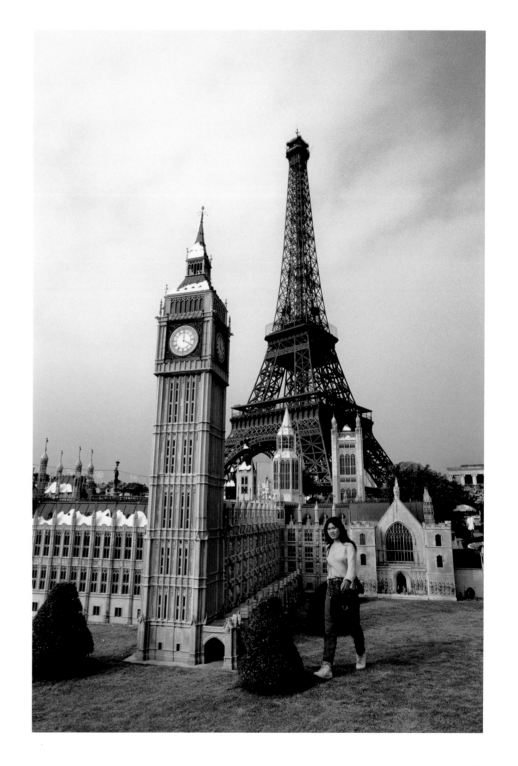

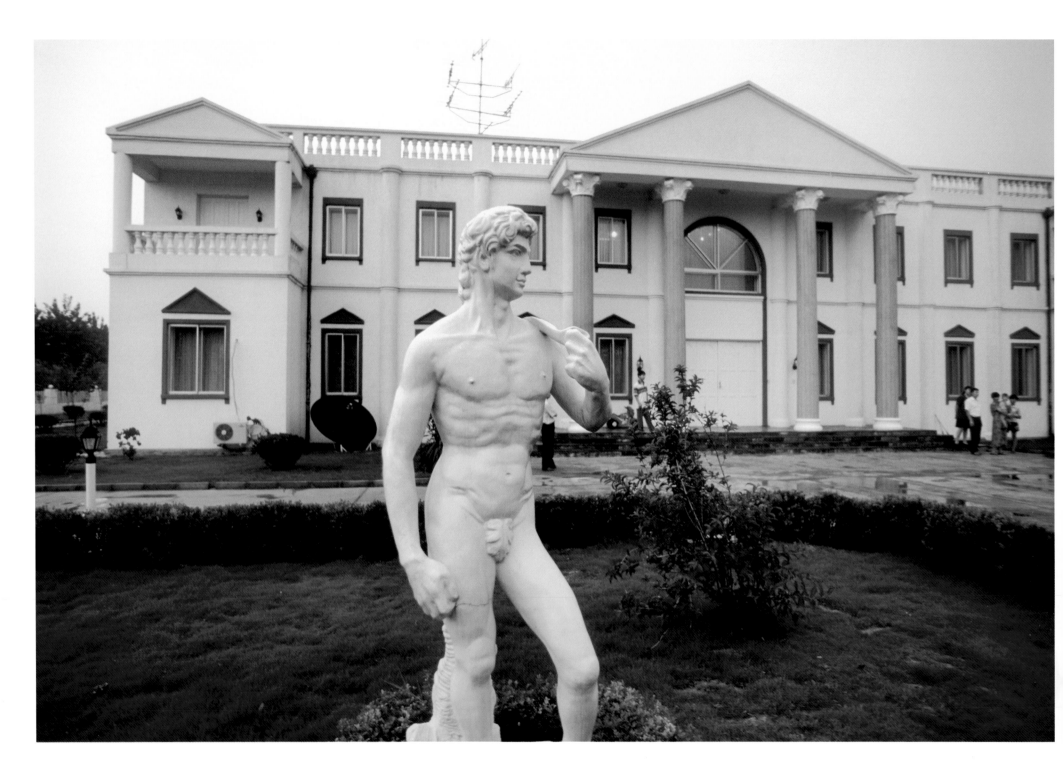

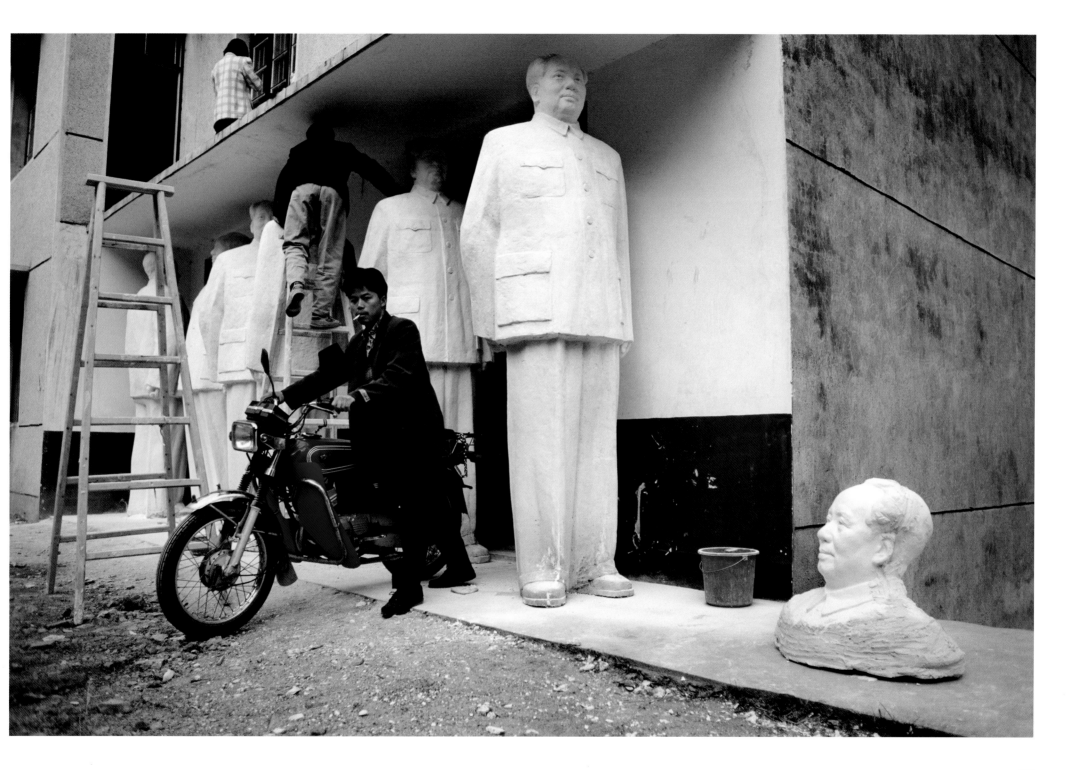

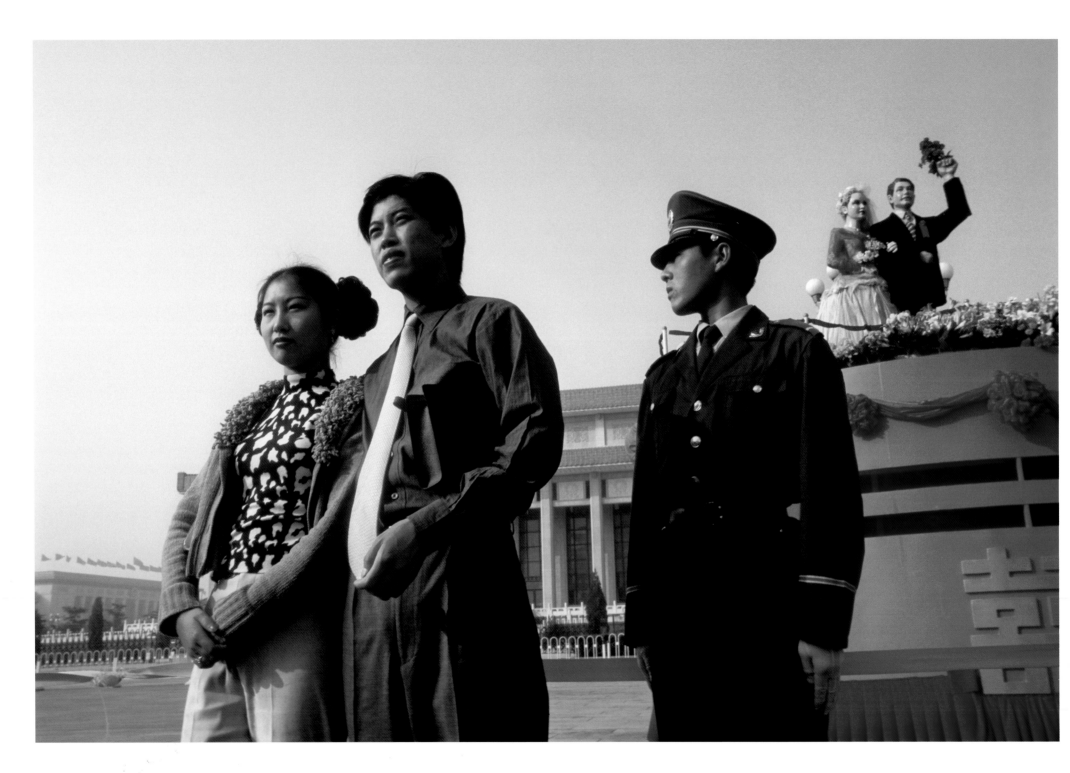

94

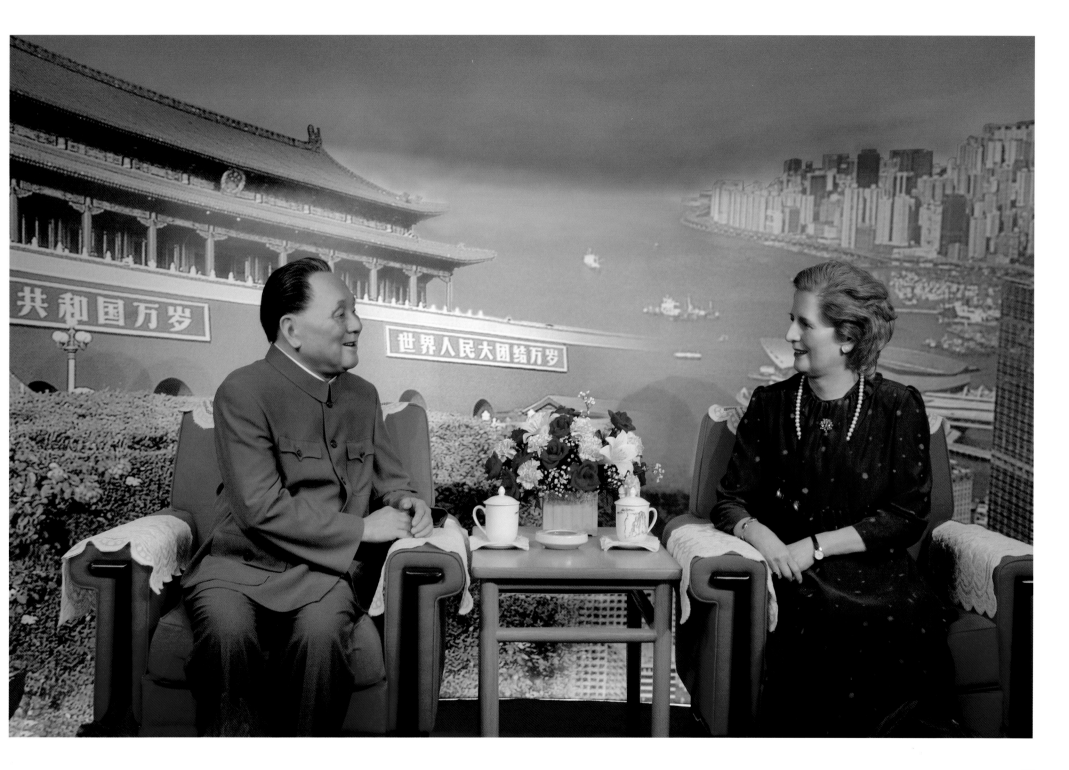

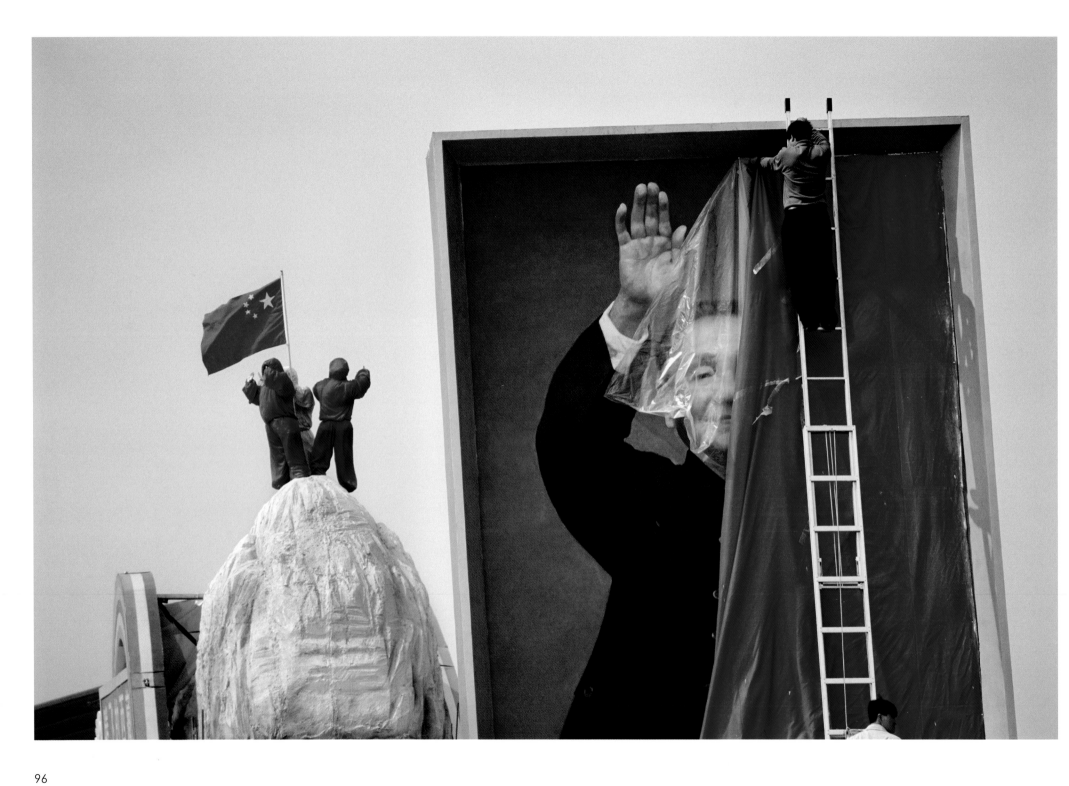

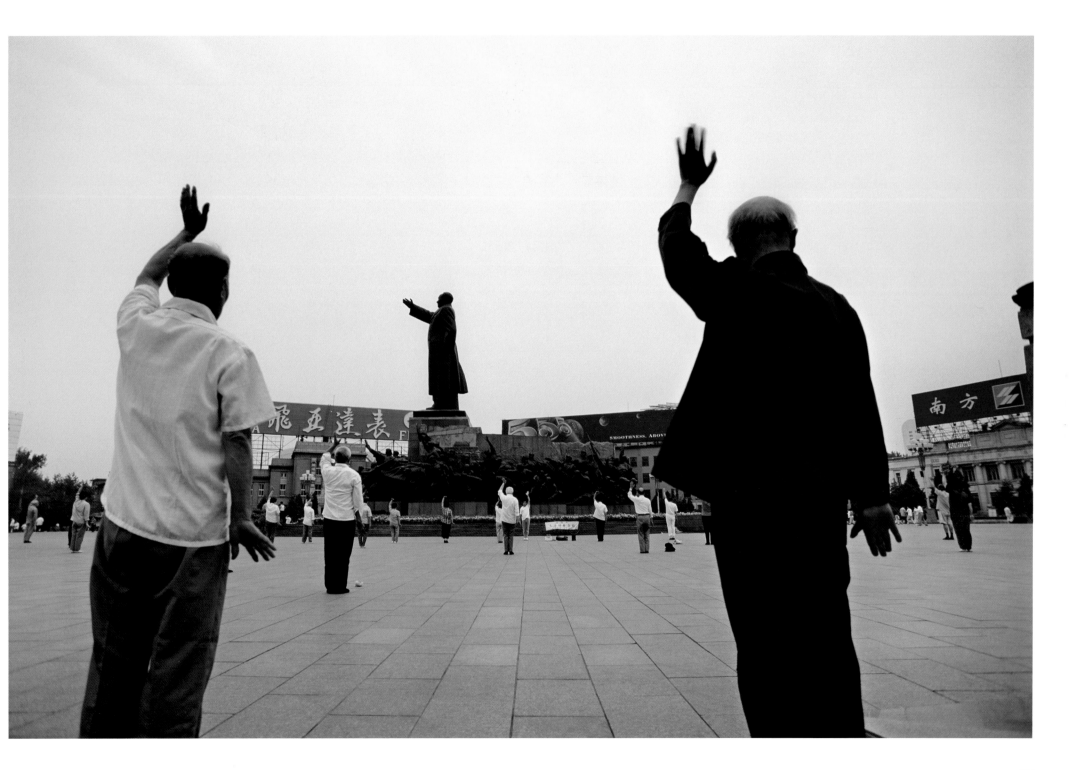

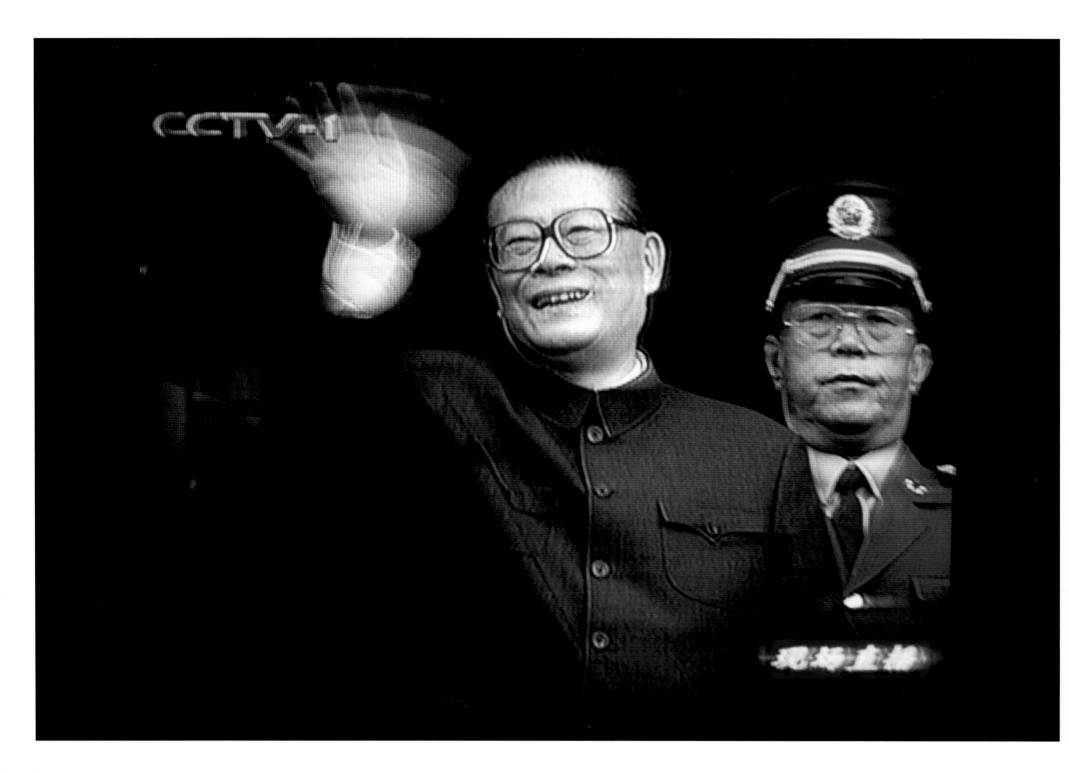

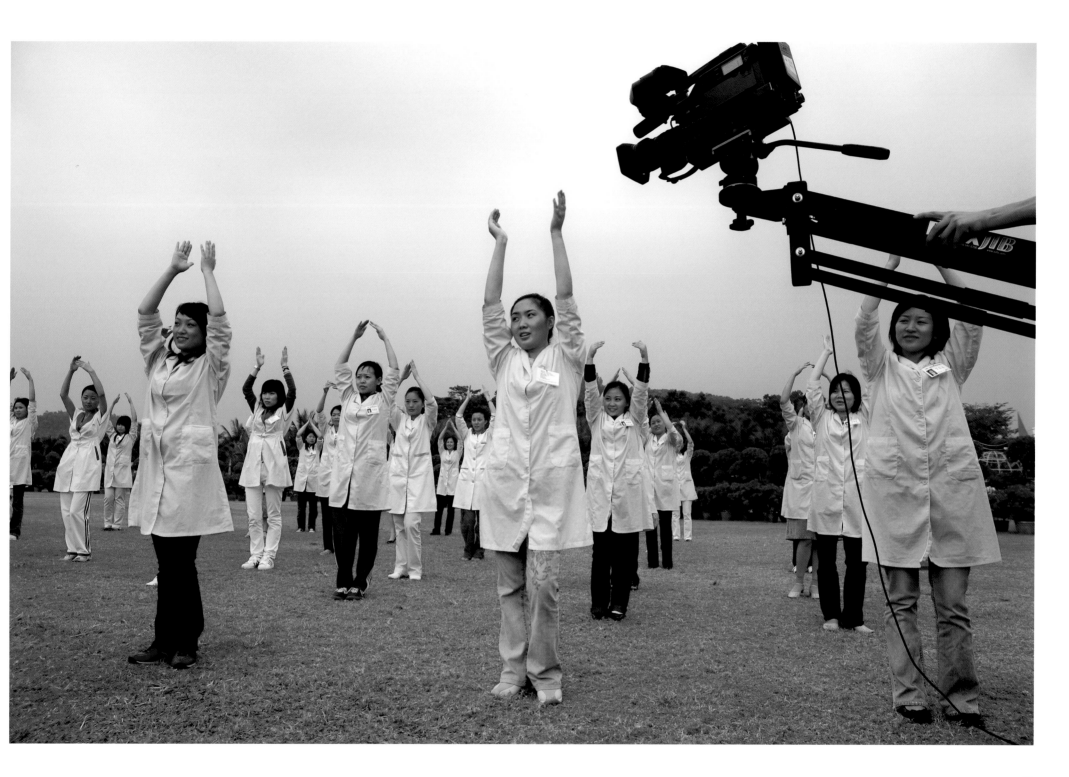

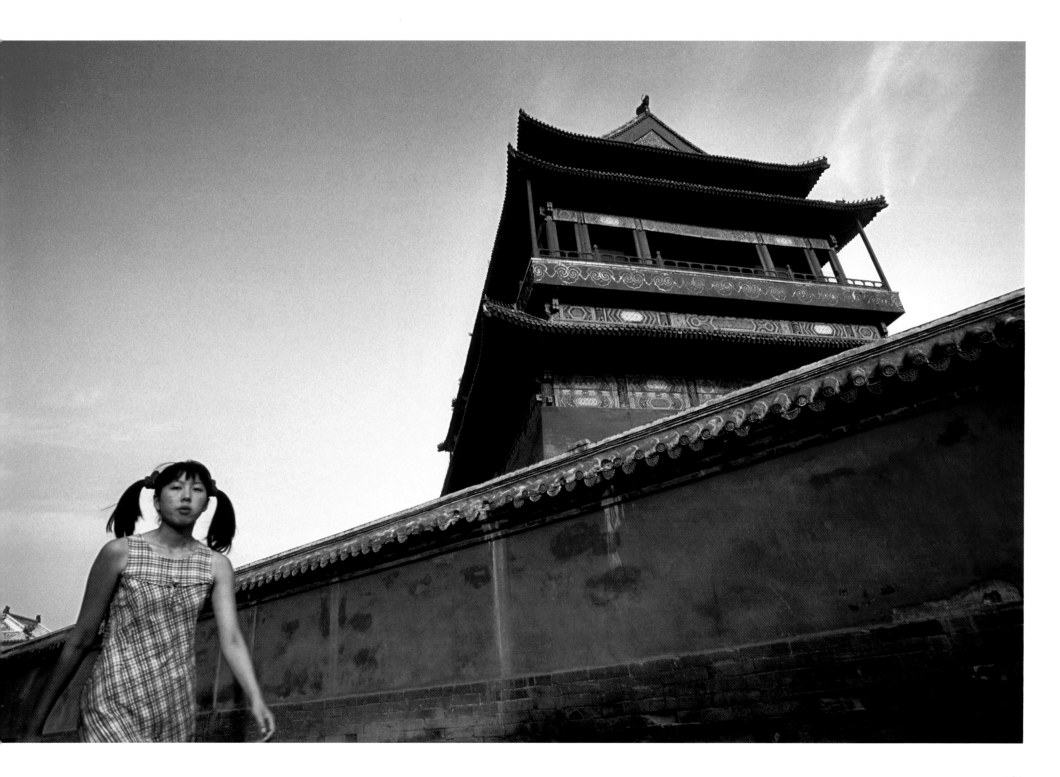

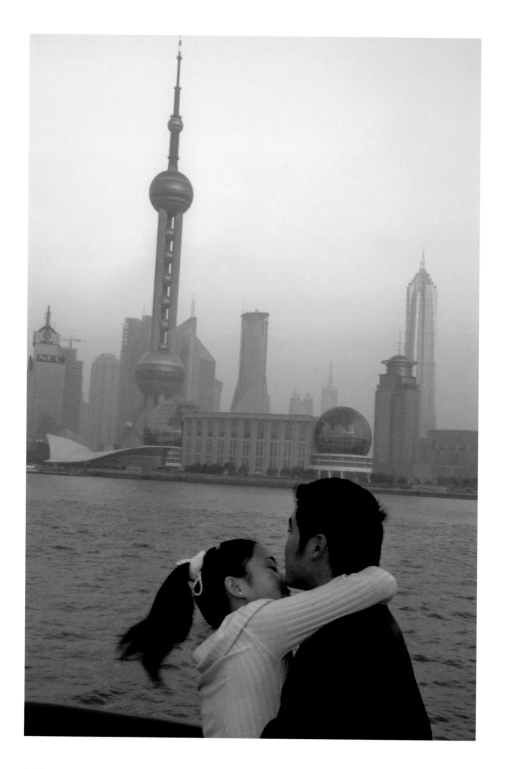

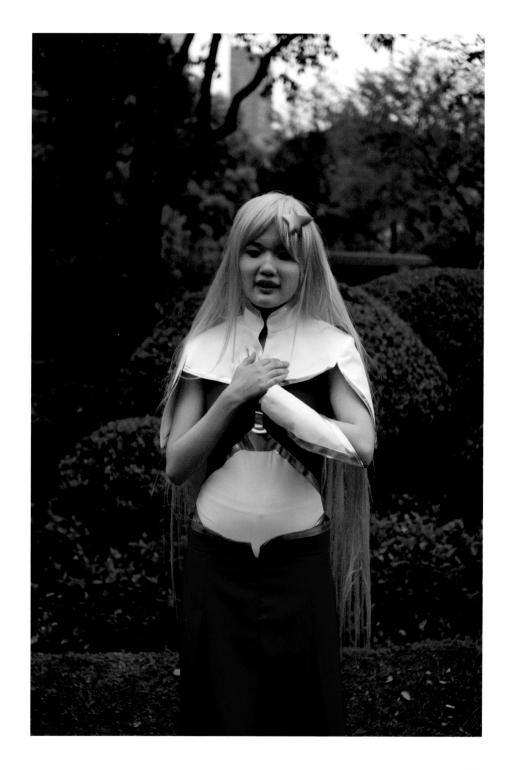

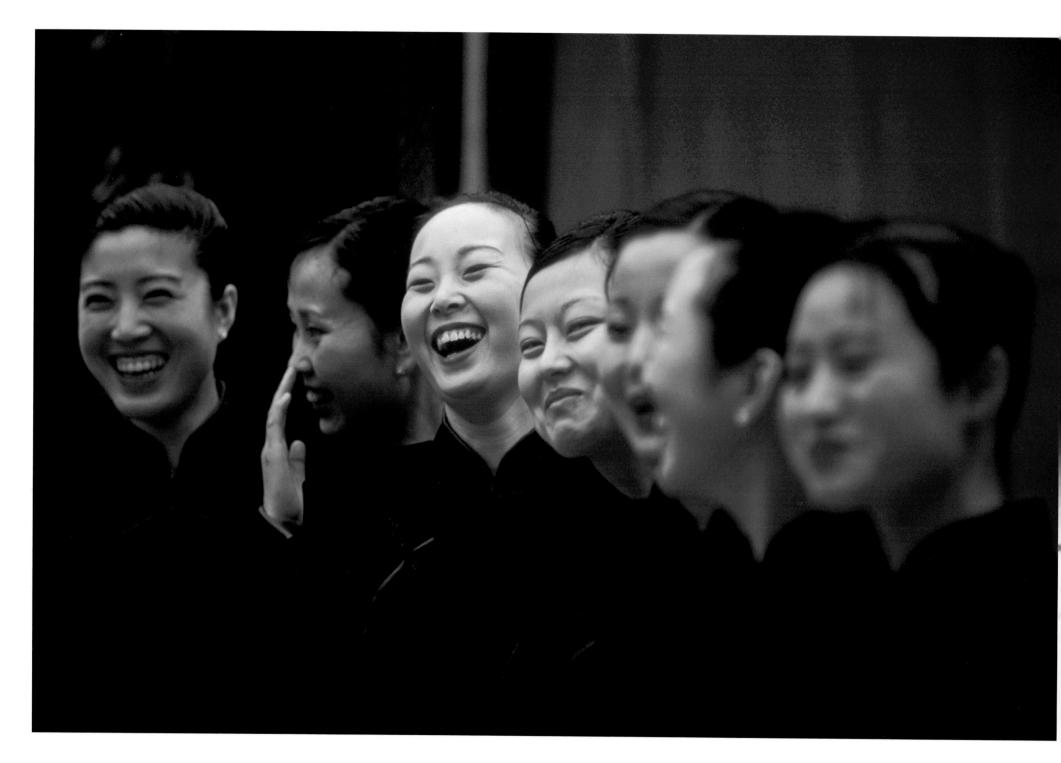

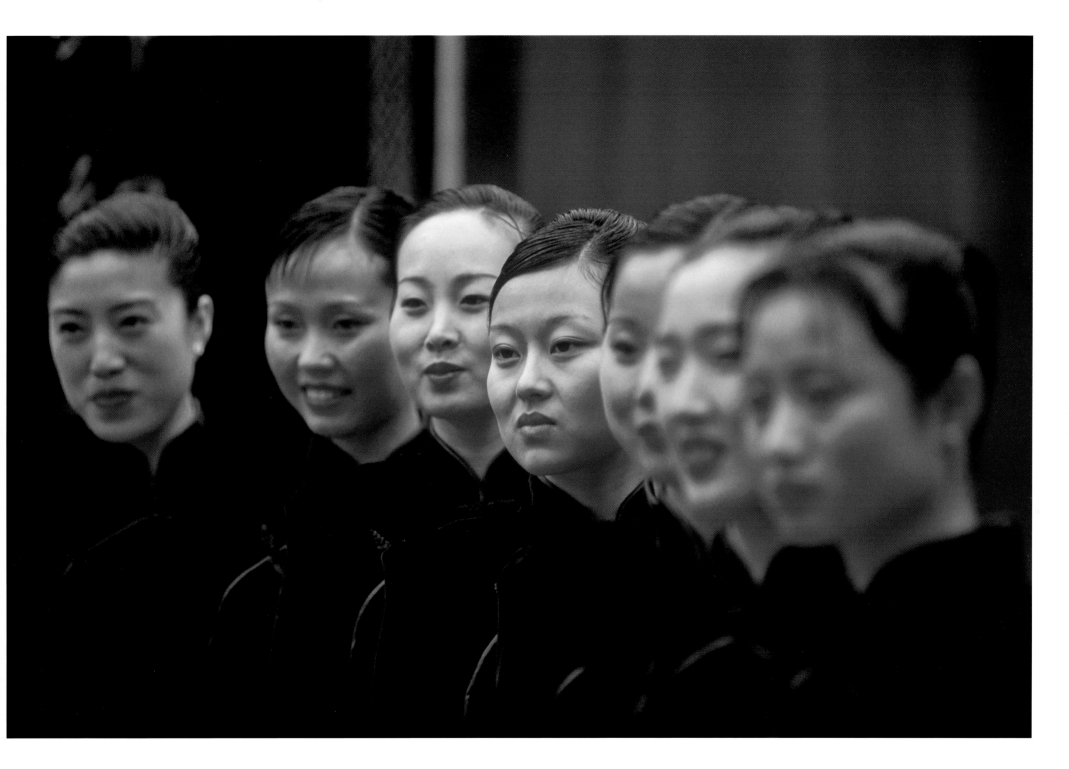

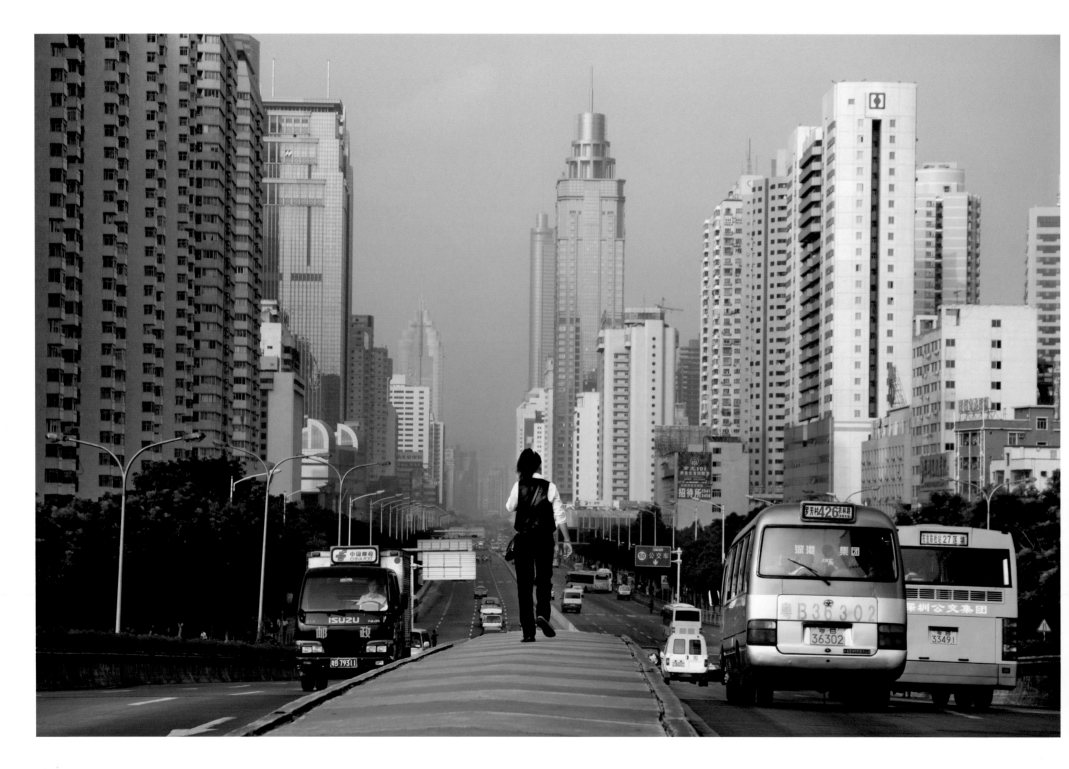

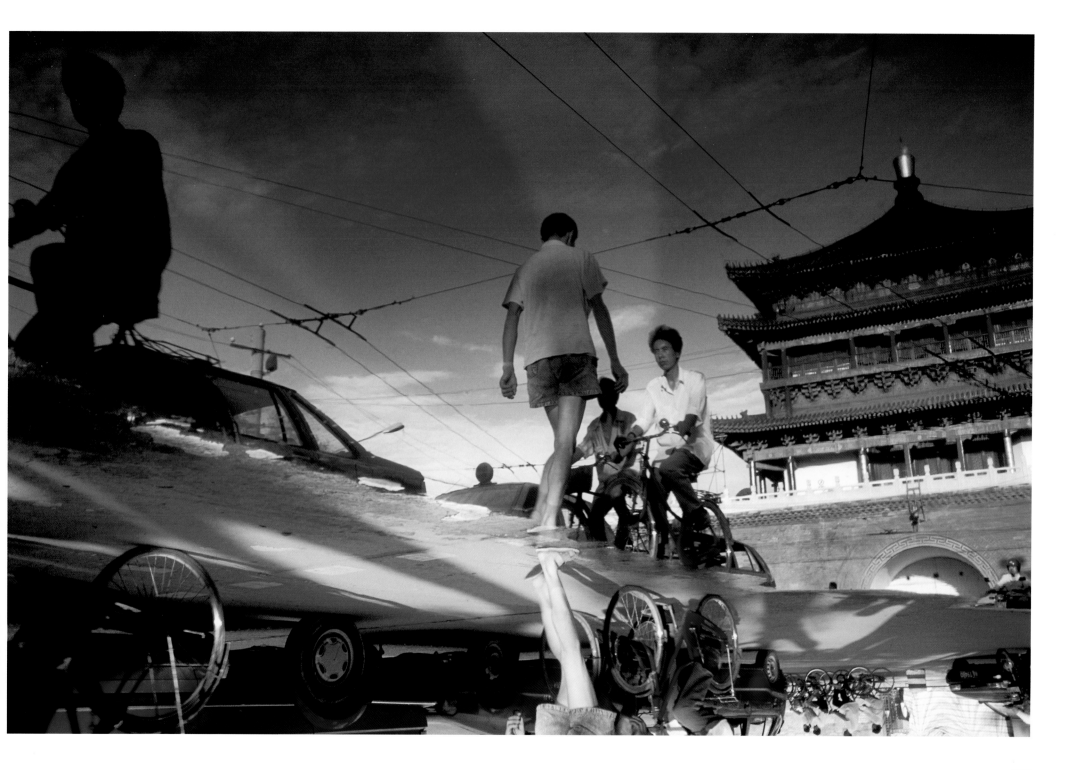

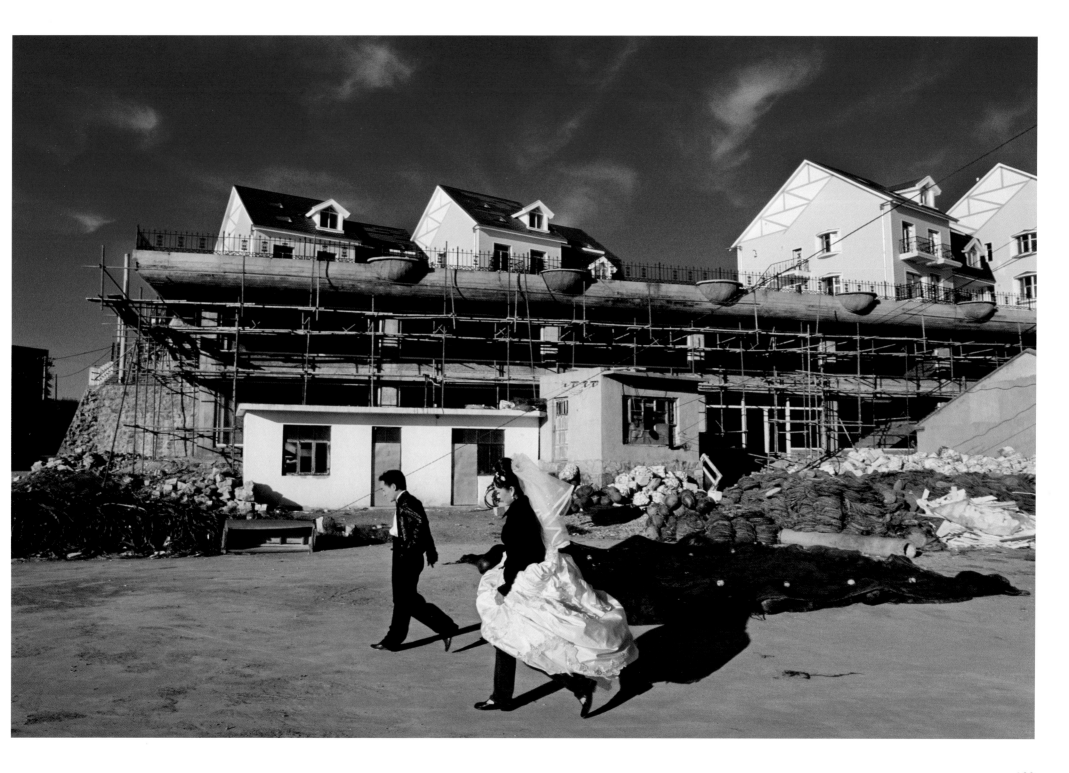

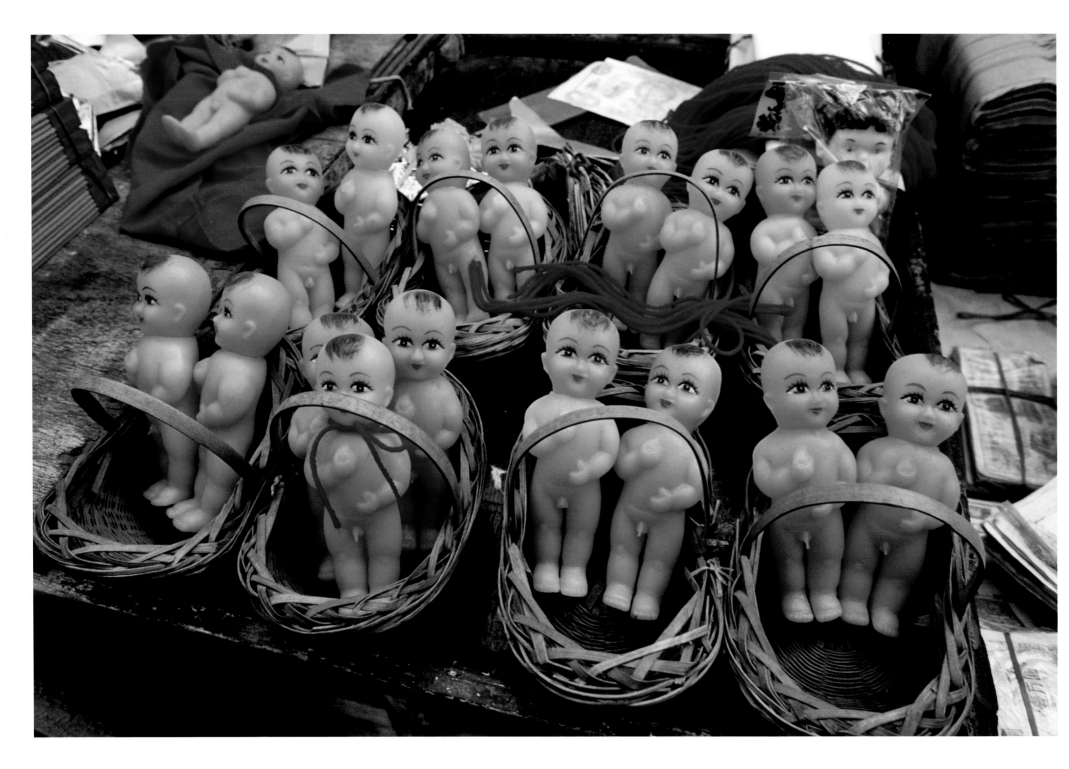

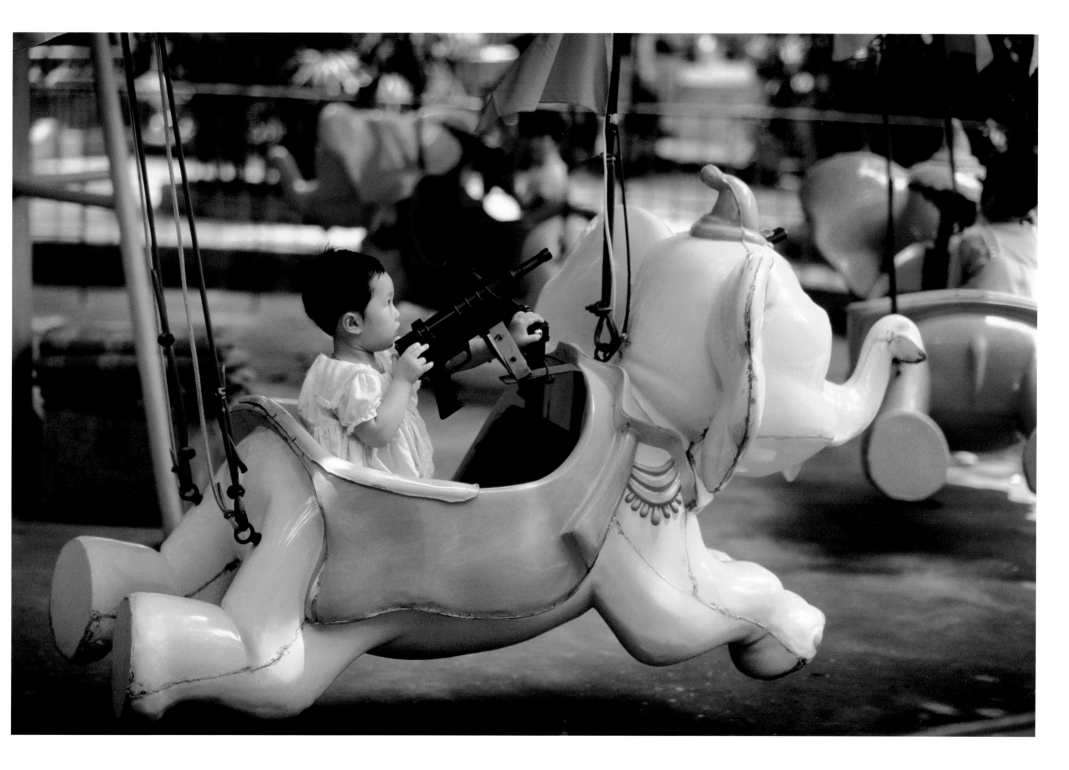

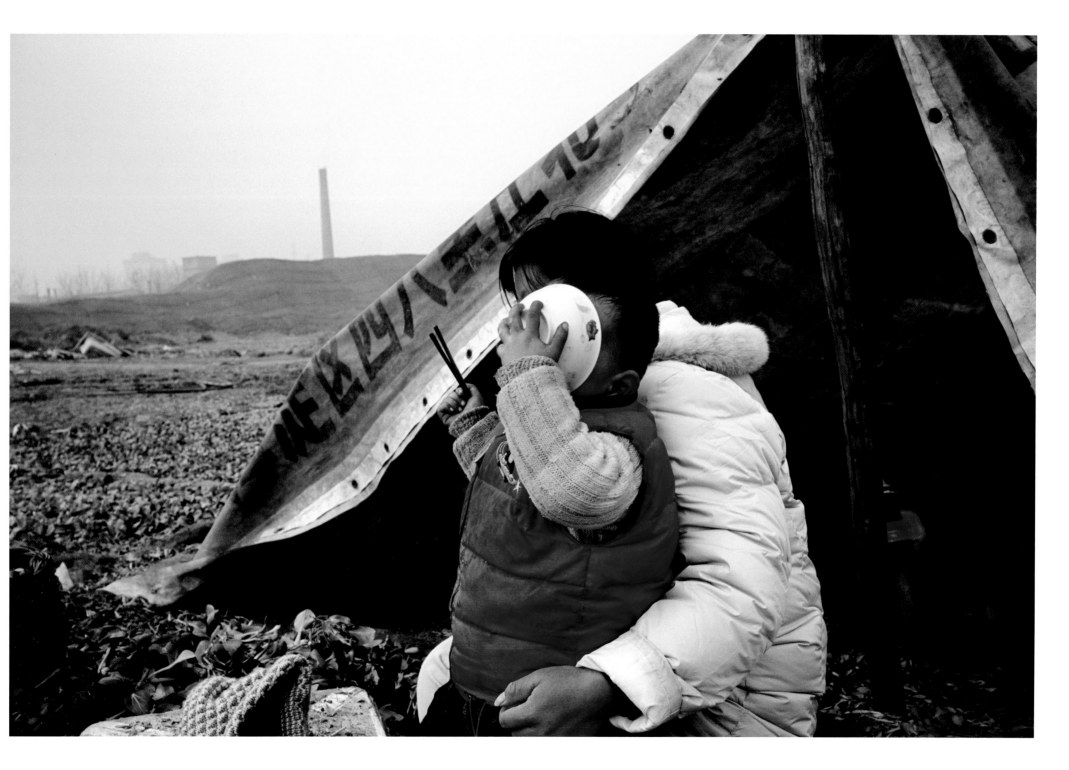

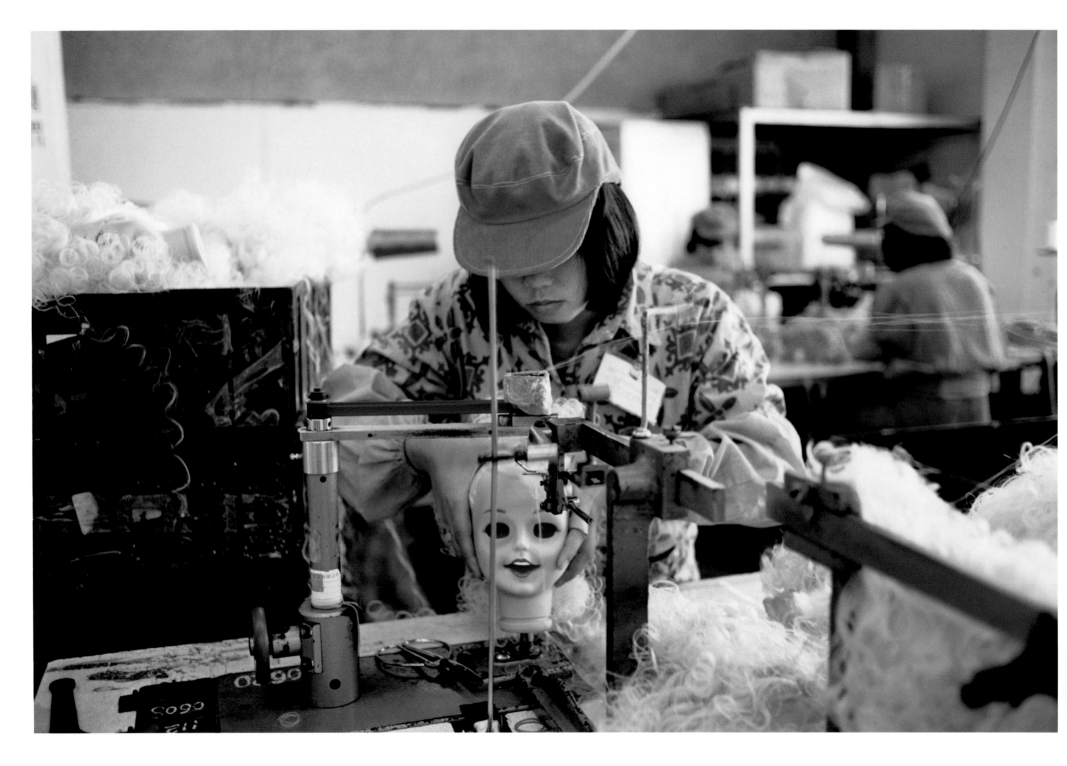

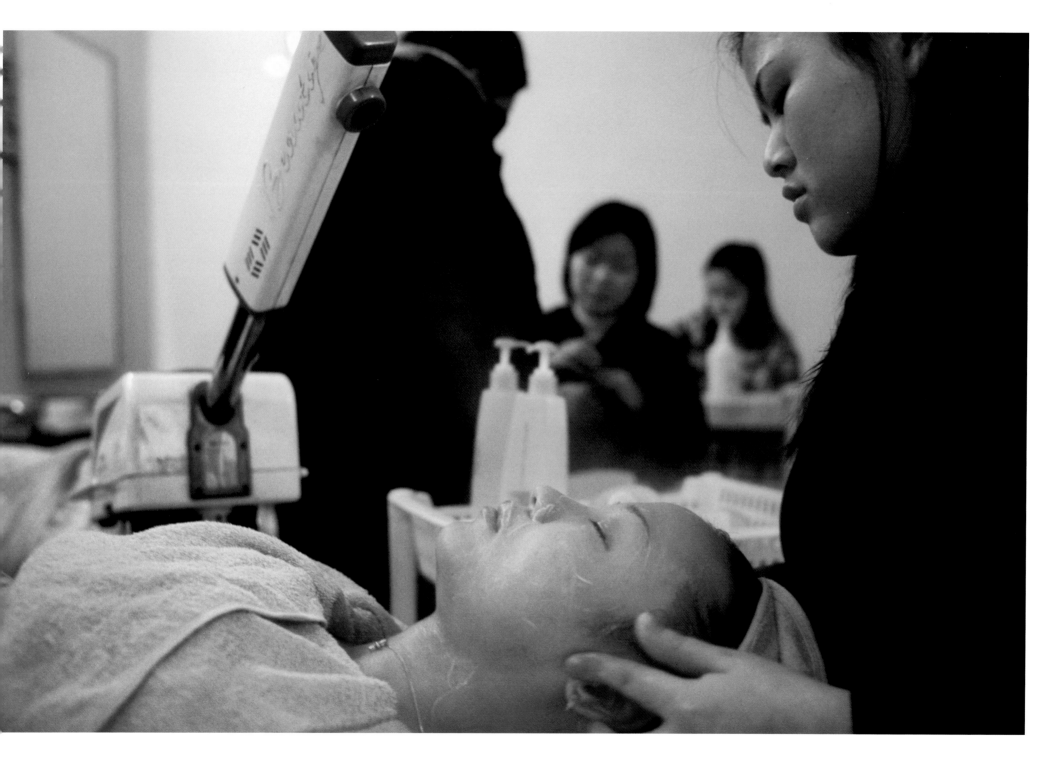

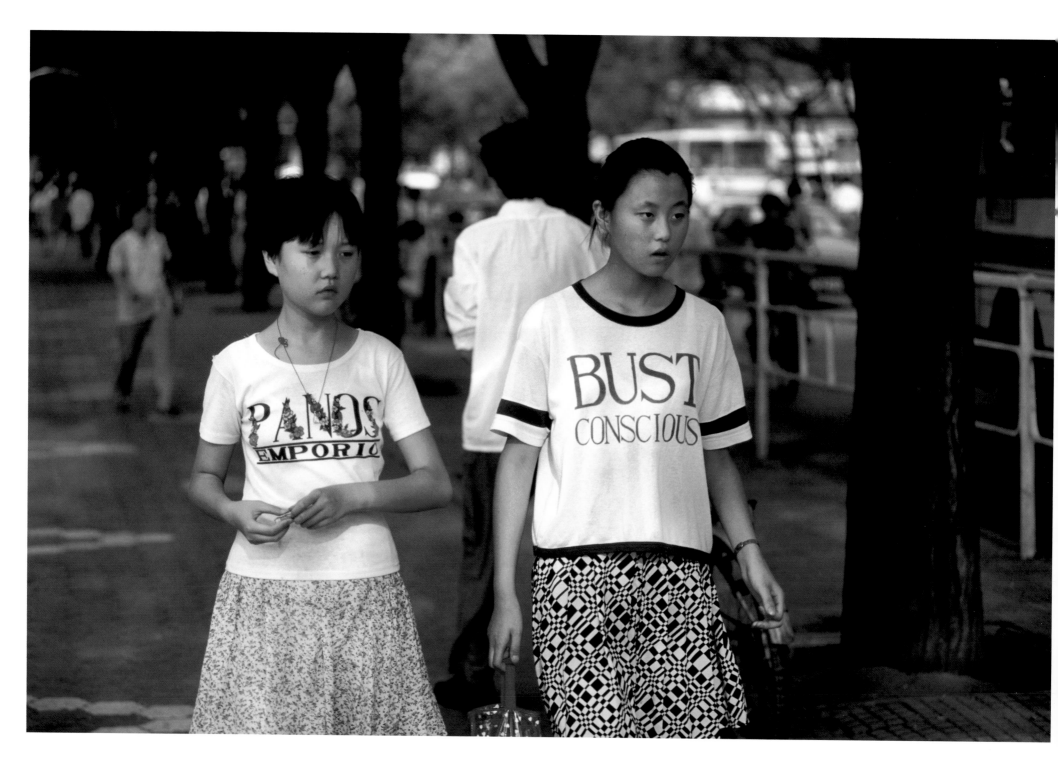

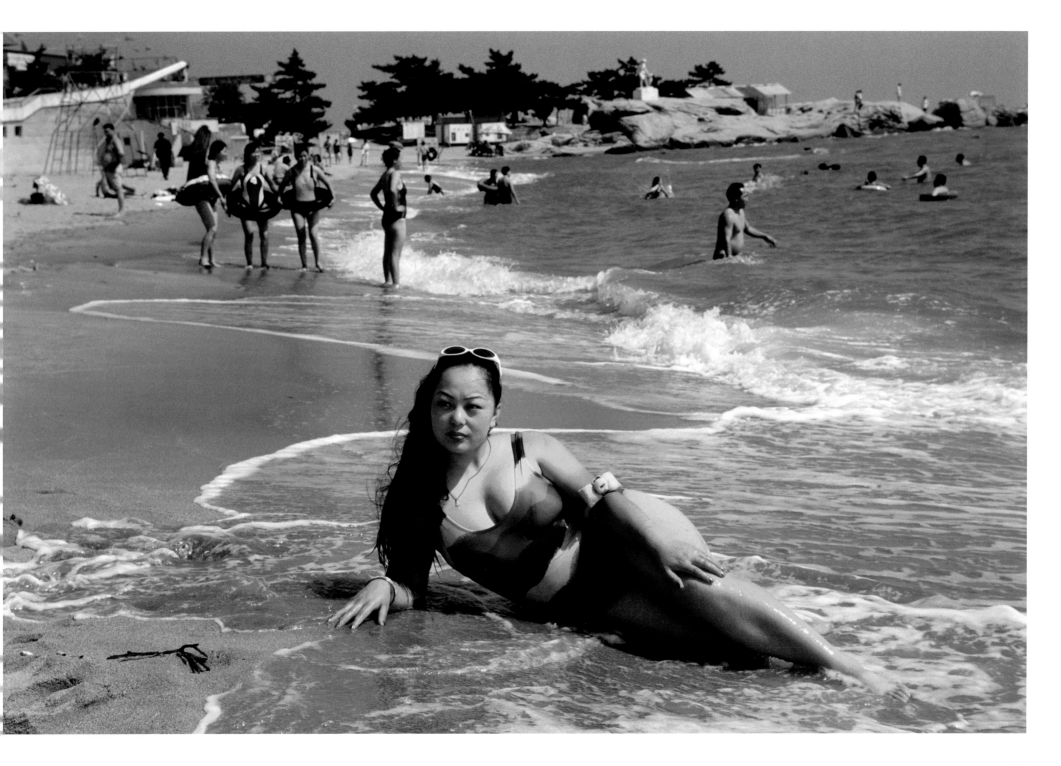

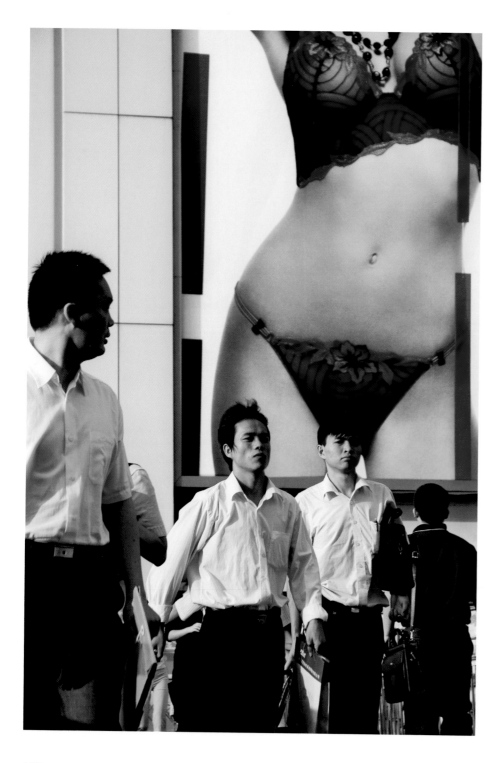

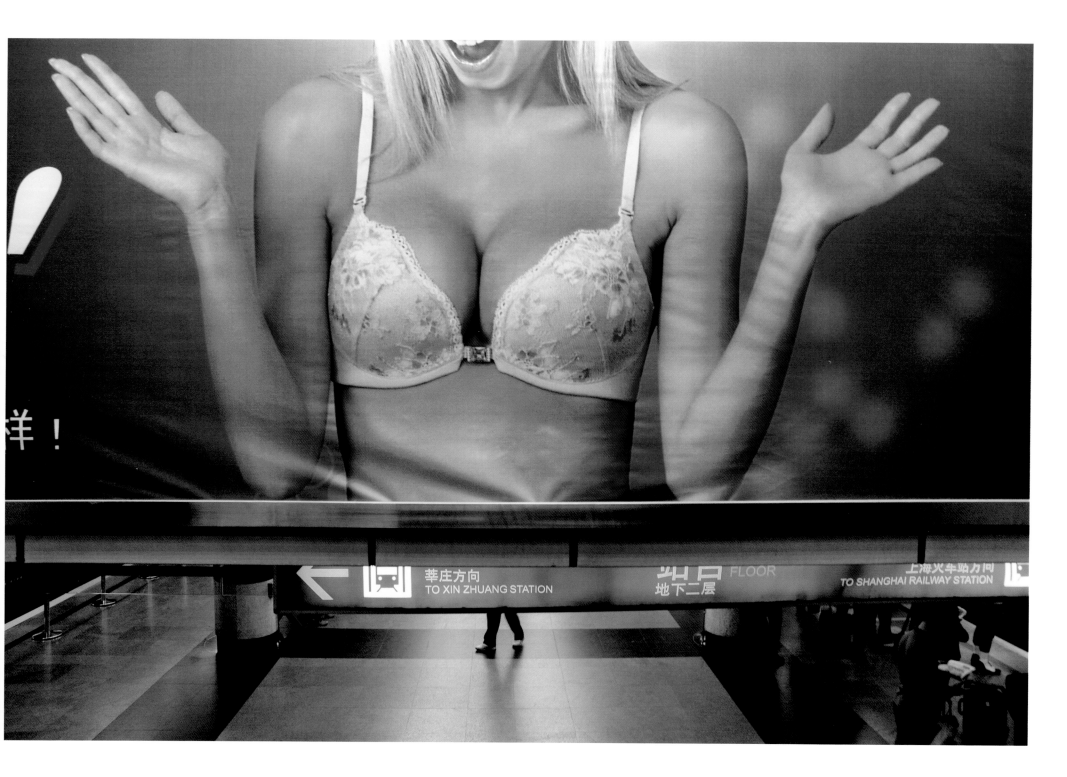

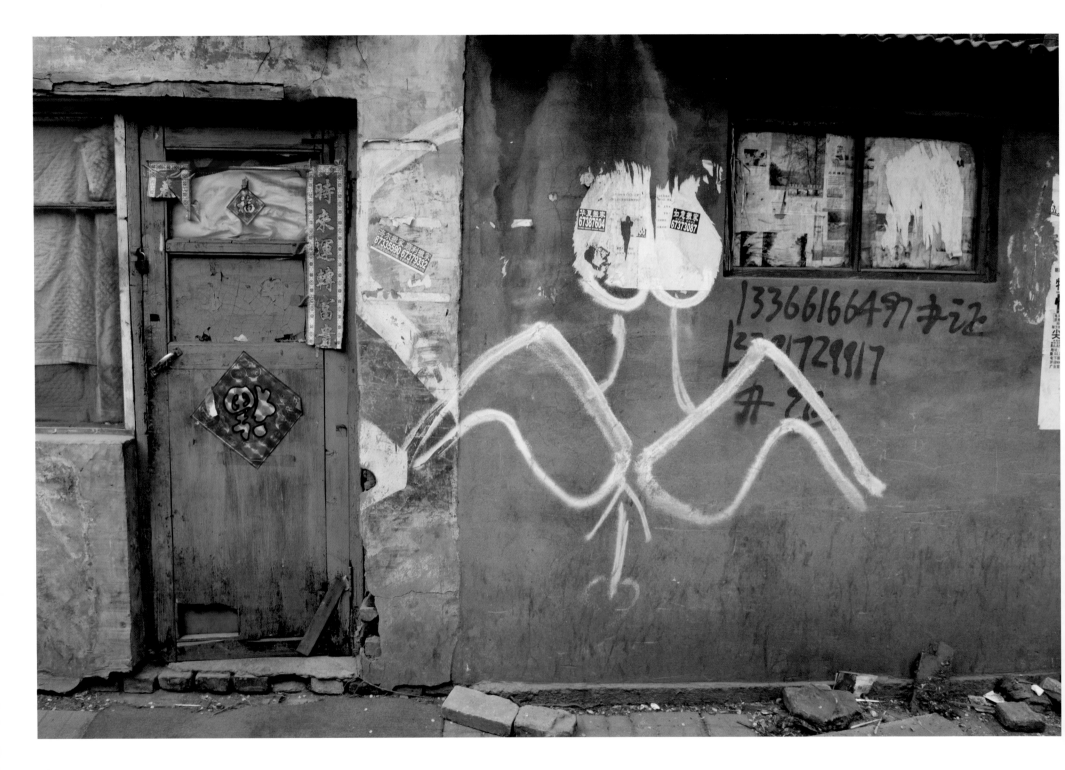

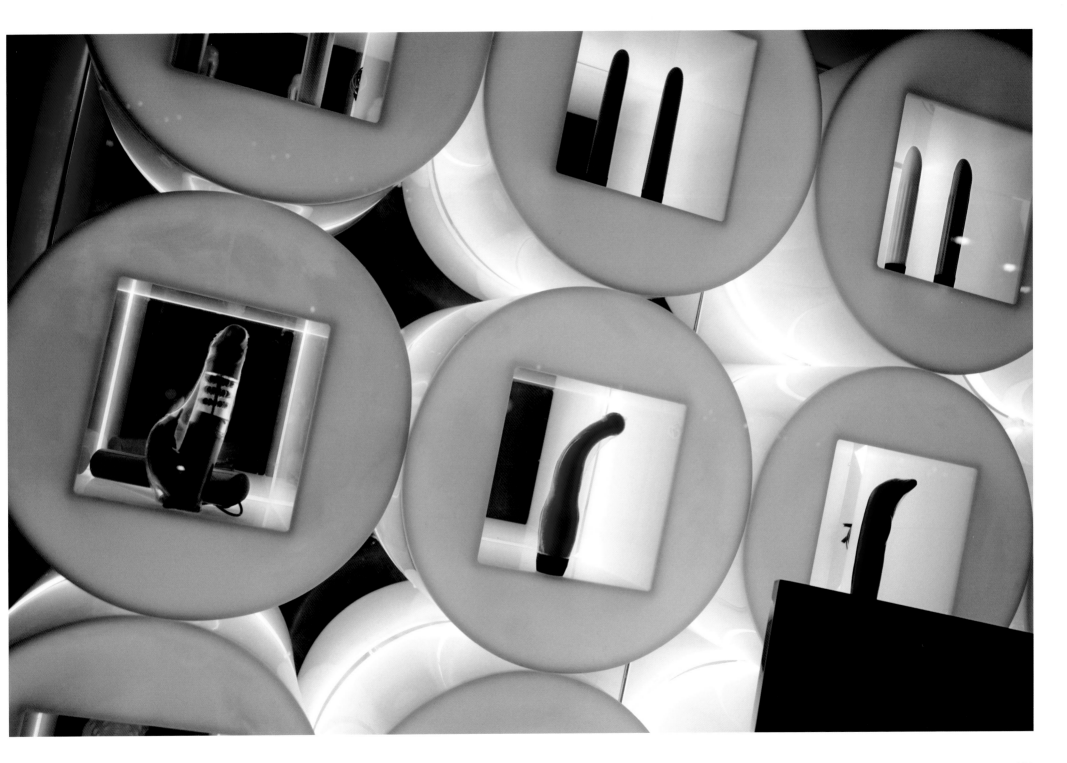

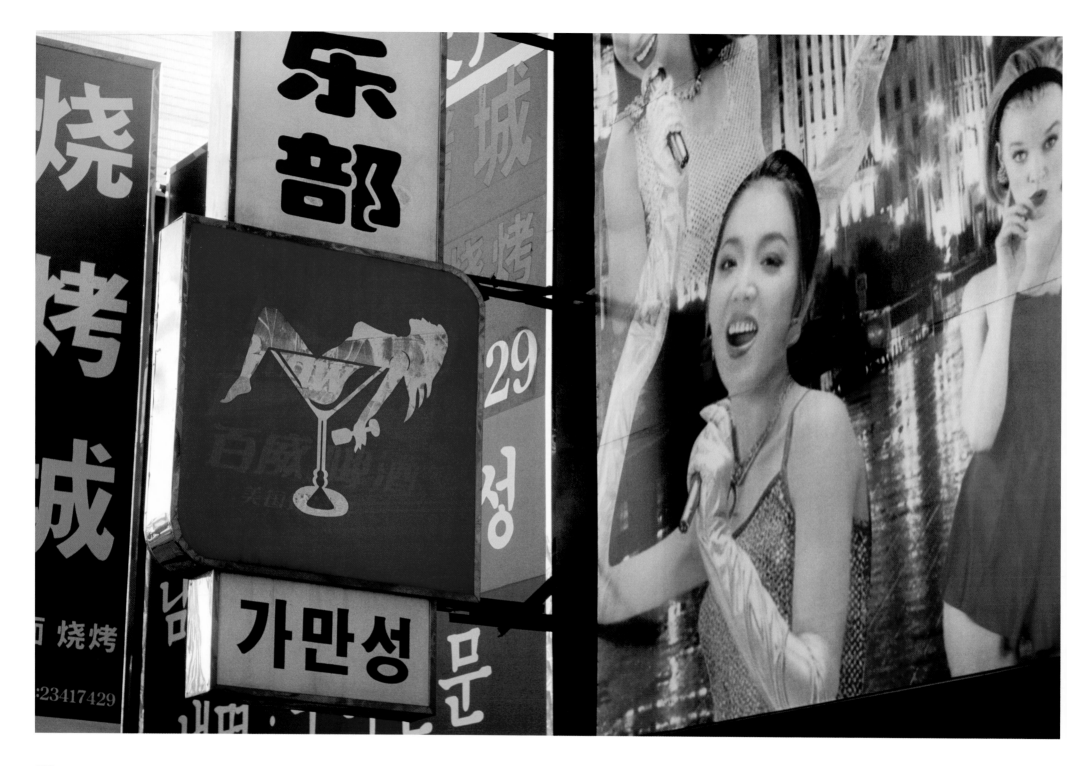

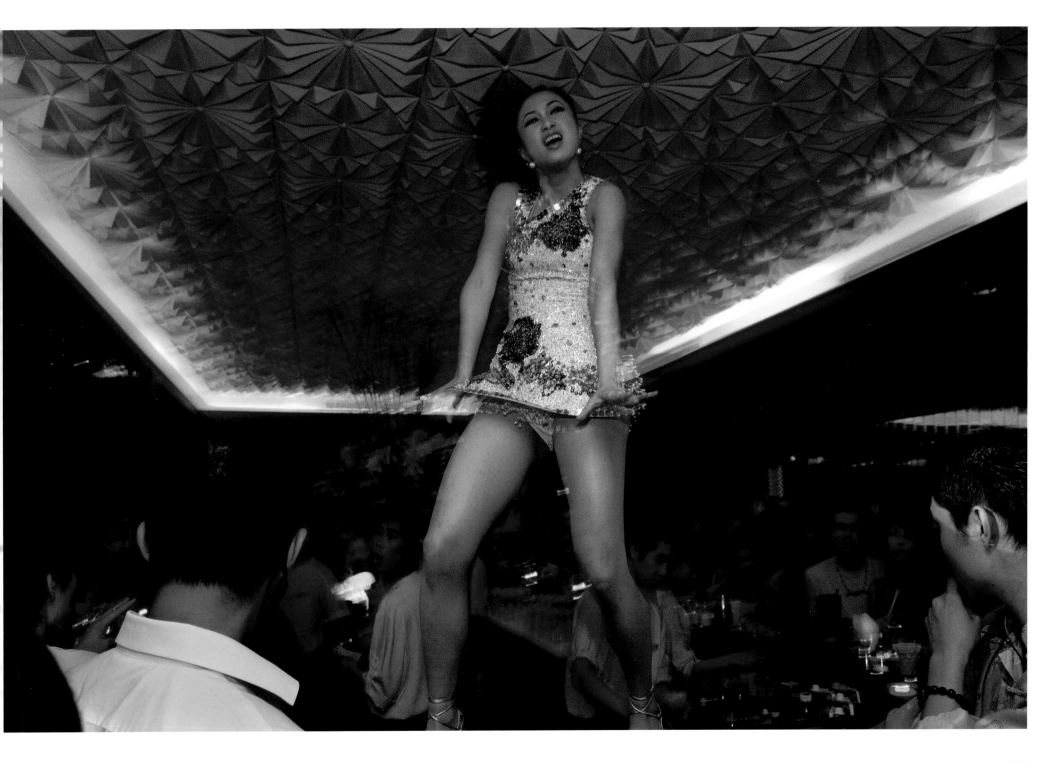

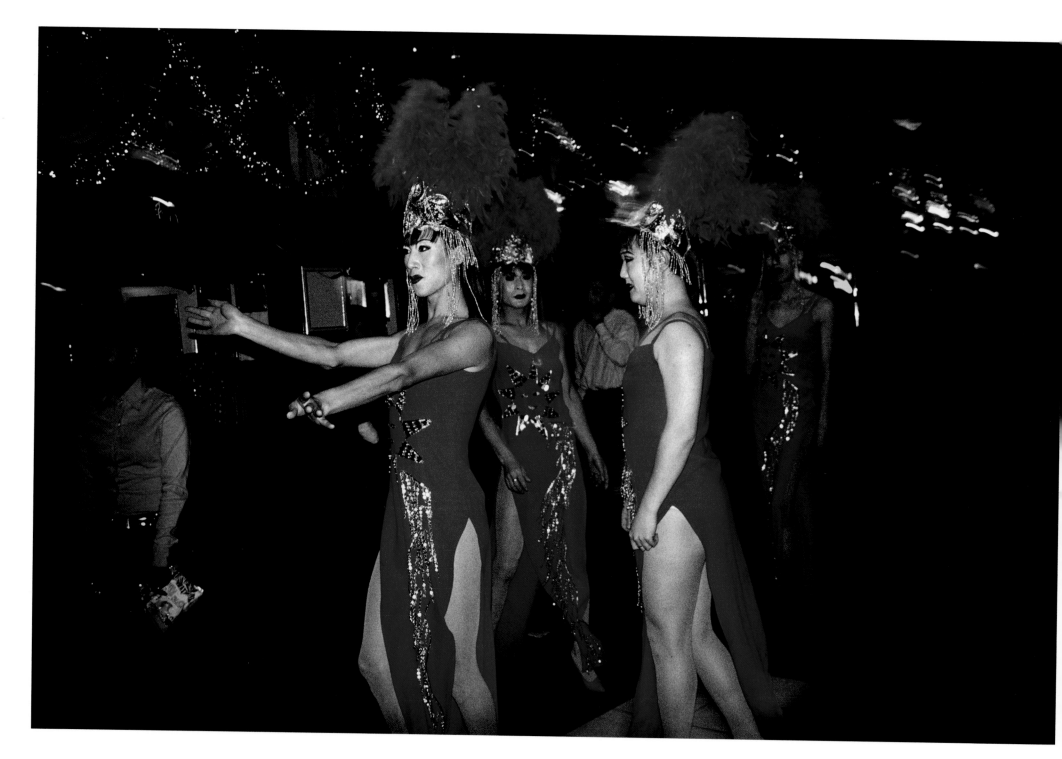

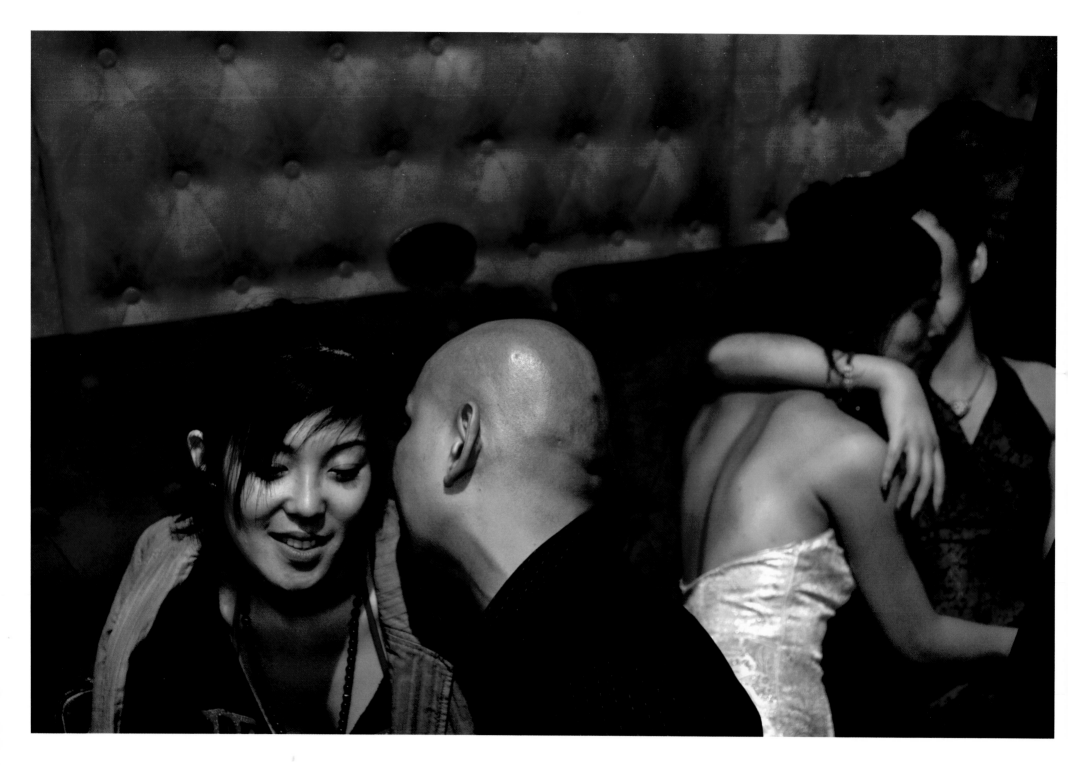

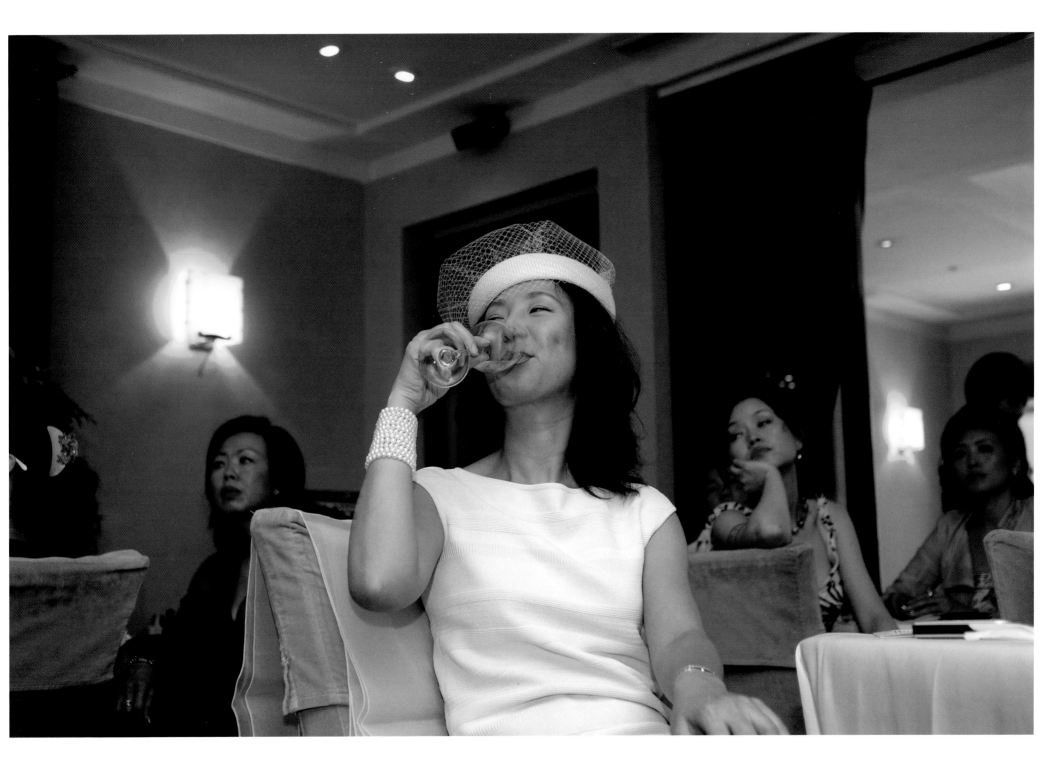

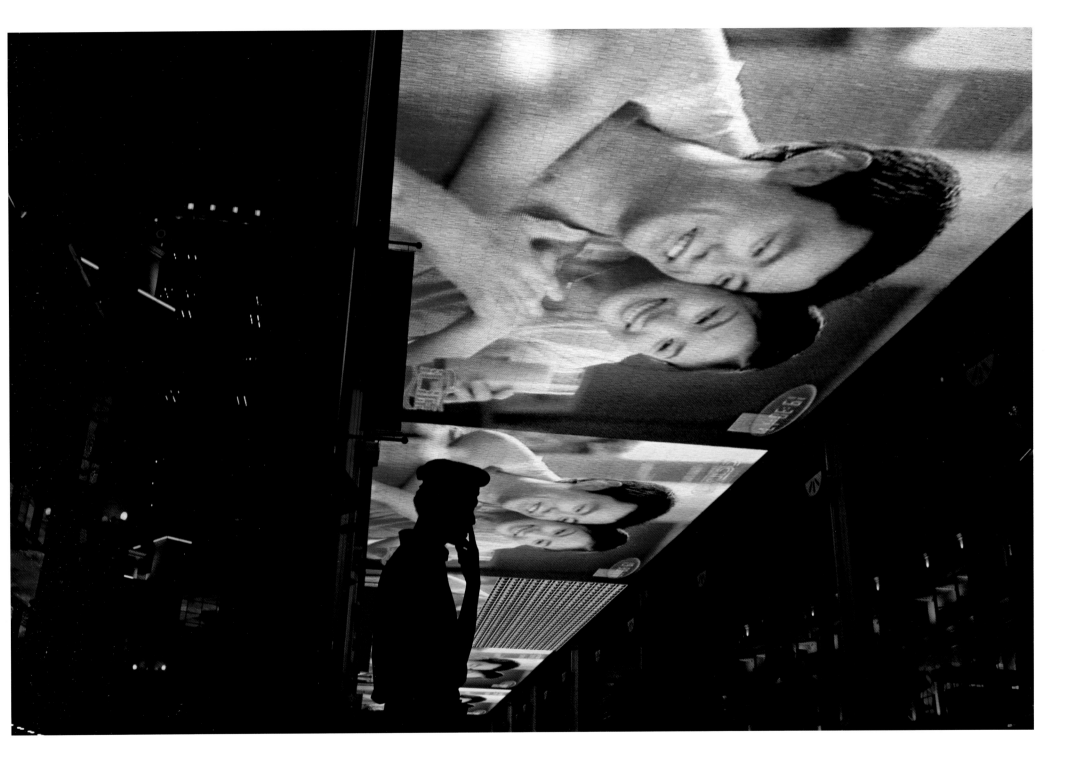

Notes

Acknowledgements

Through the China years from which this book is drawn, there are many people I would like to thank for their help in many different ways. Apart from my family, they include: Jose Albiol, Terence Billeter, André and June Brot, Clifford Coonan, Florence Domon, Cyril Dupraz, Jean-François Fournier, Olga and Hugh Fraser, Lucca Gabbiani, Florence Graezer, Leon Guan, Lisa and Andy Johnstone, Hisashi Kondo, Antoine and Tianning Ning Kernen, Marylene Lieber, Lu Xixi, Véronique Marti, Vincent Mury, Sally Neal, Taisei Ogawa, Madeline and Marc Progin, Jean-Philippe Rapp and his team at the festival Media Nord-Sud, Masaru Sugiura, Didi Kirsten Tatlow, Sonia Zoran, and many others who I hope will forgive me for having omitted their names, not least that fifth of the world's population that have tolerated my journeys through their world.

Particular thanks are also due to Nicolas Bideau for understanding my vision of China and forcing me to take the plunge on this project. The good offices and support of the Swiss foreign ministry, to which he introduced me, have been invaluable in the realisation of this book and the exhibition from which it was born, with particular mention of Alexandre Guyot and Denis Charrière at the CCC in Berne, and Lucas Schifferle at the embassy in Beijing. Also many thanks to everyone at Imagie in Geneva, and Ted Support in Yverdon for producing the exhibition prints.

Special thanks are due to my agents: to Adrian, Alex, David, John, Laura, Michael, Teresa, and Zoe of Panos Pictures in London for support and entertainment beyond the call of any duty or even last orders; to everyone at PANA in Tokyo, for their patience and fidelity over so many years; to Annie, Jennifer and the team at Cosmos in Paris; to Antonio at Ropi and to Richard at Sinopix.

From the final stages of the preparation of this book in Beijing, I would like to say a particular thank you to Eliot Kiang for so generously giving his time and skills to bring form to my chaos, to Qian Cheng for diving in to save us, and to Stephen Shaver for keeping me on the rails, celebrating my 'wrong moments', and distracting me just when I needed it most. Qilai Shen and Dermot Tatlow also deserve a special thank you for similar services in Guilin and beyond. I am also gratefully to the many people who have offered advice and encouragement, not least Robert Bernell my publisher and Ed Lanfranco who also kindly contributed the introduction to this book.

Madeleine. Without you, none of this would have been possible. Thank you. For everything.

Beijing, October 2006

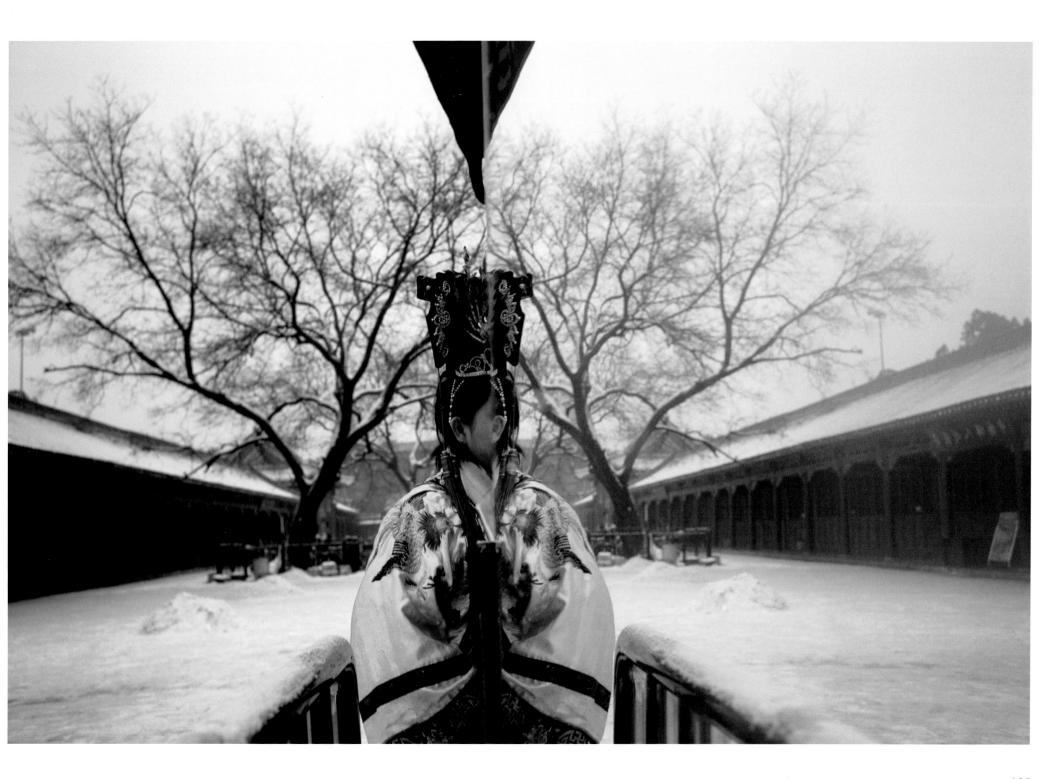